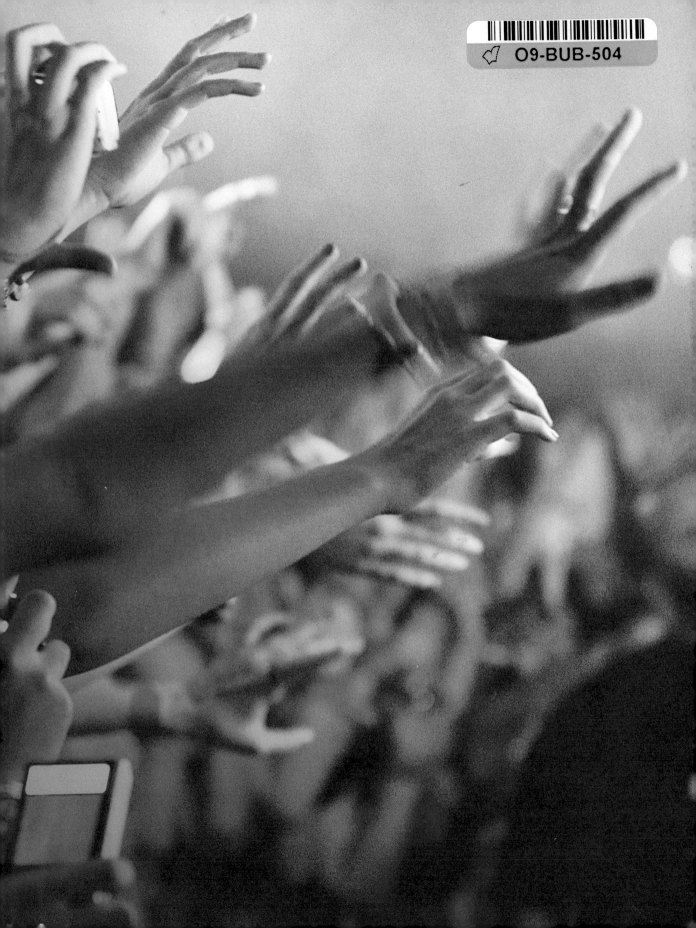

# 100% OFFICIAL
# JUSTIN BIEBER
## JUST GETTING STARTED

**HARPER**

*An Imprint of HarperCollinsPublishers*

Justin Bieber: Just Getting Started

© Bieber Time Books LLC, 2012
All rights reserved. Printed in the United States of
America. No part of this book may be used or reproduced
in any manner whatsoever without written permission
except in the case of brief quotations embodied in
critical articles and reviews.

For information address HarperCollins Children's Books, a
division of HarperCollins Publishers, 10 East 53rd Street,
New York, NY 10022.

www.harpercollinschildrens.com

Library of Congress catalog card number: 2012945142
ISBN 978-0-06-220208-6

Justin Bieber asserts the moral right to be identified
as the author of this work

Design by Taylor Cope Wallace

12  13  14  15  16   LP/RRDJC   10 9 8 7 6 5 4 3 2 1
❖
First U.S. edition, 2012

All images are © Mike Lerner, with the
following exceptions:

p17, p47, p72, p106 and p159 (overlay) ©
Sergey Peterman; p19 and p66 (bottom
left) © Carin Morris; p37, p63 (top left and
right), p66 (top and middle), p71 (inset
middle and inset right), p97, p101, p102
(top and middle left), p122, p170 (top),
p173, p187 (bottom right), p194 (inset),
p215, p227 and p231 (inset left) © Alfredo
Flores; p51 © Ohpix; p71 (inset left) ©
James "Scrappy" Slassen; p108 (top and
middle left) Someday by Justin Bieber
fragrance shoot © Terry Richardson; p108
(bottom right) © Gregory Pace/BEI/Rex
Features; p111 © Dimitrios Kambouris/
Wirelmage/Getty Images; p112 © Warner
Bros. Entertainment Inc., all rights
reserved; p126 and p231 (inset right)
© Justin Bieber; p139 (top and bottom)
and p170 (bottom) © Beverly News/Rex
Features

While every effort has been made to trace
the owners of the images produced herein
and secure permission to use them, the
publishers would like to apologize for
any omissions and will be pleased to
incorporate missing acknowledgments
in any future edition of this book.

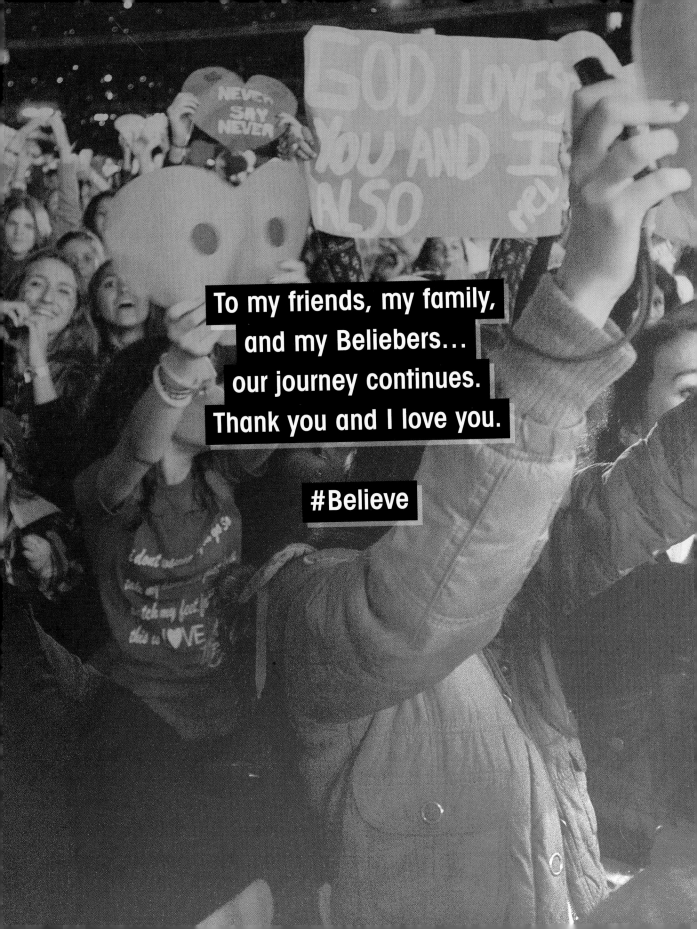

To my friends, my family,
and my Beliebers…
our journey continues.
Thank you and I love you.

#Believe

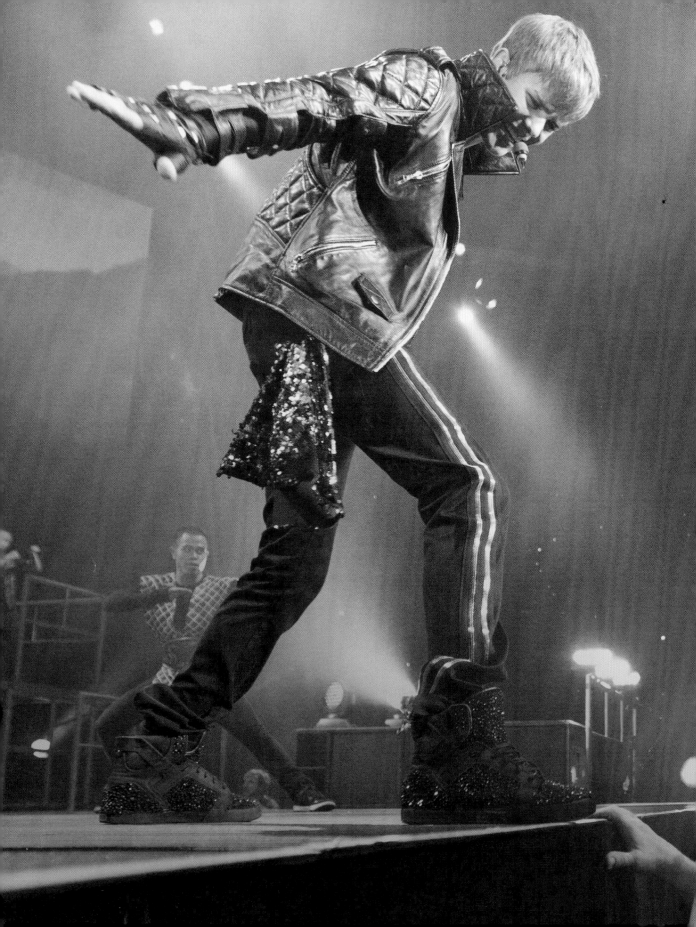

# CONTENTS

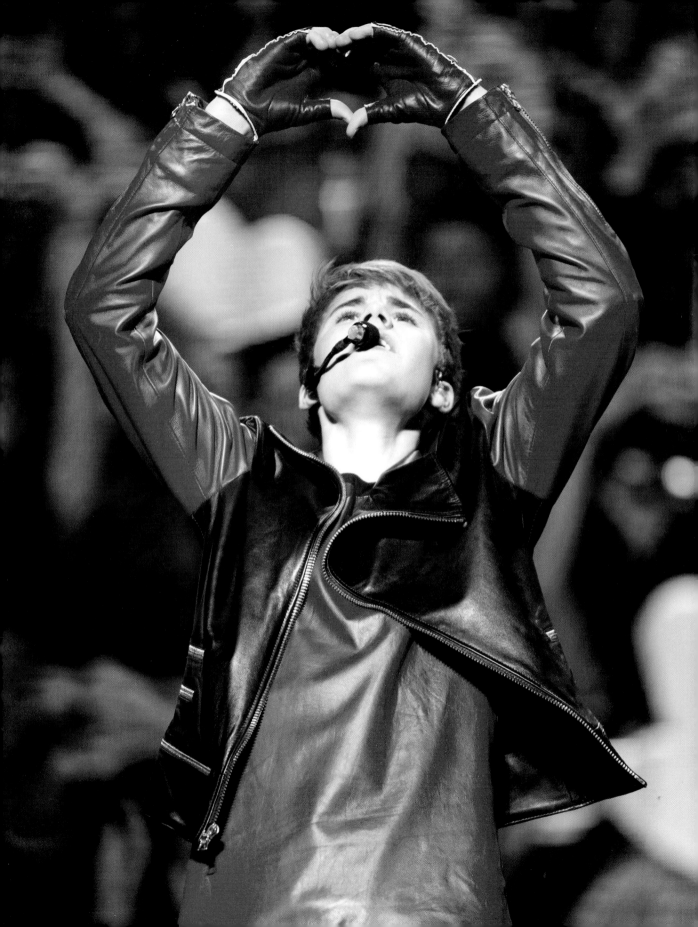

# CHECKING IN

I didn't grow up with aspirations to become a big pop star. I just wanted to be a regular kid who does all of the normal things other kids do. I started posting videos on YouTube when I was 12 so my family could hear me sing. I never knew it was going to be a big thing. I mean, we were just posting videos, and a month or two later, out of nowhere, tons of viewers were watching. I come from a little town in Canada called Stratford, with a population of 30,000 people, and that made all of this even crazier. I never thought I'd get to do anything other than maybe become a carpenter and maybe one day turn that into a business. The mere thought of becoming a star didn't even seem possible. It was like going to the moon or winning the lottery. But, a couple of years later, by the time I was 14, I was no longer just singing for my family—the world was hearing me sing too. The rest is history.

"You can do anything if you put your mind to it —just look at me. The harder you work, the more successful you can be. This is just the beginning..."

When I first started posting my videos, my mom and I weren't looking to help me get discovered. I mean, if we were, we probably would have left our small town and headed to LA to do auditions and casting calls. No way. That wasn't the route we were on, and in the end, that wasn't the road that led me to where I am today.

A lot of people think I was an overnight success, but that wouldn't be exactly true. Sure, it's only been five years, but it has also been a lot of hard work that took time, sacrifice, and relentless dedication. Plus, five years in the life of a guy who is now 18 years old is a pretty long time. Some people think hard work is—well, too hard. Me? It's all I know and a big part of the formula for success. I like doing what I do so much that I don't spend a whole lot of time sleeping. I'd rather be working hard, doing my thing, and striving to become the very best entertainer I can be. I want to be great at what I do—to become the best performer in the world. To do that, I need to keep striving continuously to get better, to be good to people, to treat everyone with respect and work as hard as I can. These are traits I'd hope to develop whether I was famous or not.

People always ask me how I do it—you know, what's my secret to success. I tell them not to be afraid to do the things in life that scare you or that you think are too hard to handle. Do what I do, and run toward them, embrace those challenges as opportunities and see how fast your life will change too!

I wouldn't be anywhere if it weren't for you—my fans. *You* are the reason I get to do what I love. Without your love and support I couldn't keep creating my music and sharing it with everyone all over the world. Everywhere I go, whatever I do, I try to connect with as many of you as possible—and that means everything to me.

I have always had a real direct relationship with my fans because each of you has played an important part in helping me reach every goal I've set for myself along the way. Without a doubt, you have impacted every step that has made up this crazy roller coaster journey. When I am feeling down, you lift me up. It's just like I sing in my song, "Believe," where I talk about how my fans have always been there for me—I mean every word. This book is my way to let you know what all of this has been like for me and how you have helped me get through it all.

Sharing my stories of being on the road is just another step in our journey together—another chapter along the way. My story is something I like to share with others, to show people that with enough belief in yourself and what you can accomplish, *anything* is possible.

This book is a look at what life is like for me both on and off the road. I hope you'll enjoy this behind-the-scenes peek, your personal backstage pass to my world. I am truly one of the luckiest guys on the planet, because I get to wake up every day doing what I love most—touring, playing, and making music, and traveling all over the world. But most of all, I wake up grateful for you, my Beliebers. You were there from the very start, and I will never forget that. Thanks to you, I get to live my dream every day.

"Thank you" doesn't begin to cover how appreciative I am—but from the bottom of my heart I want to say thanks for being there and for all of your support. Let's keep doing what we do, and together we can keep the dream going. Look out world 'cuz *I'm Just Getting Started*.

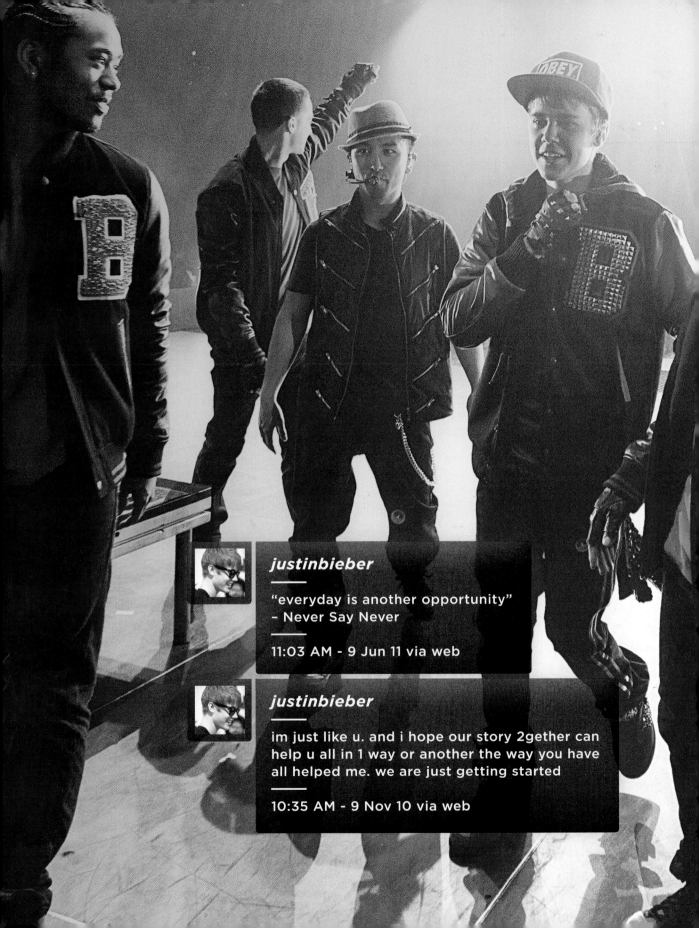

**_justinbieber_**

"everyday is another opportunity"
– Never Say Never

11:03 AM - 9 Jun 11 via web

**justinbieber**

im just like u. and i hope our story 2gether can help u all in 1 way or another the way you have all helped me. we are just getting started

10:35 AM - 9 Nov 10 via web

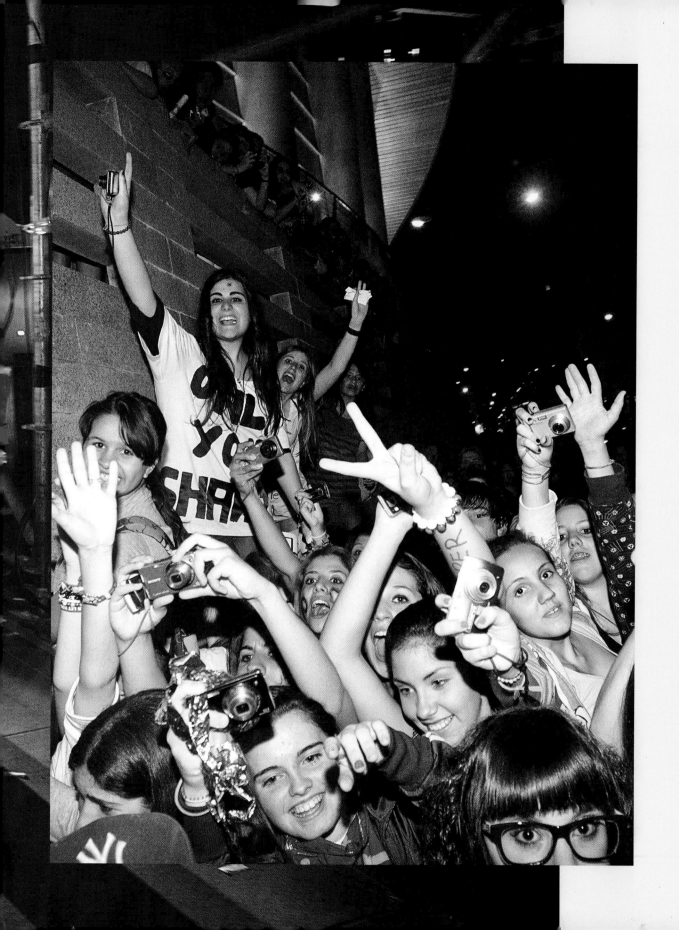

# CHAPTER 1

# JUST GETTING STARTED

## LEG ONE

I still feel like a regular kid. Sometimes it's weird that I go places and I have thousands of people waiting for me, but I always think,

"I'm Justin..."
--

In Mexico City. I always try to connect with my songs when I'm singing live. It's amazing when it works, when it's just me and the music.

# NEW YORK, NEW YORK

August 31, 2010

Before I saw my first show at Madison Square Garden I wasn't totally aware of the significance of playing to a sell-out crowd at the legendary venue, but at the end of the day I understood that it is one of the most famous arenas in the world. Back then it was sometimes hard for me to fully grasp what things like this meant because I was so young and new to the business, but when my manager, Scooter, sat me down and told me this is where the Beatles, Frank Sinatra, and Michael Jackson have all played, the scope of how big this was quickly began to sink in. I guess I understood that for Scooter and the rest of the world, playing MSG is a gigantic achievement for any artist. But for me, it became important because of Taylor Swift.

Now, you might be wondering why it was Taylor who got my attention over all the other artists who have played there over the years. The answer is pretty simple. The Garden is where I first saw her perform to a sell-out crowd in August 2009. Plus, that was my first time seeing a real arena show with an audience full of fans with their hands in the air connected to the artist. That night I looked at Scooter while we were standing in the pit and said, "This is what I want to do for the rest of my life." Before he could respond, I added, "And ... I want to sell this arena out."

Scooter smiled and said, "Look, I'm sure you will sell it out someday, but at the moment you are still at the beginning of your career and it will probably take a couple of years."

A couple of years? Was he kidding?

I wanted to sell it out in the next year. I didn't care how hard I had to work. That was my goal. And I meant it too.

So, as far as everyone else was concerned, playing the Garden was a historic and monumental thing—proof that we had made it. But for me it was a goal—an "impossible" goal that everyone thought a kid made famous from his own channel on YouTube, who didn't come from a TV talent show or sitcom and didn't have a significant enough "platform," could never pull off.

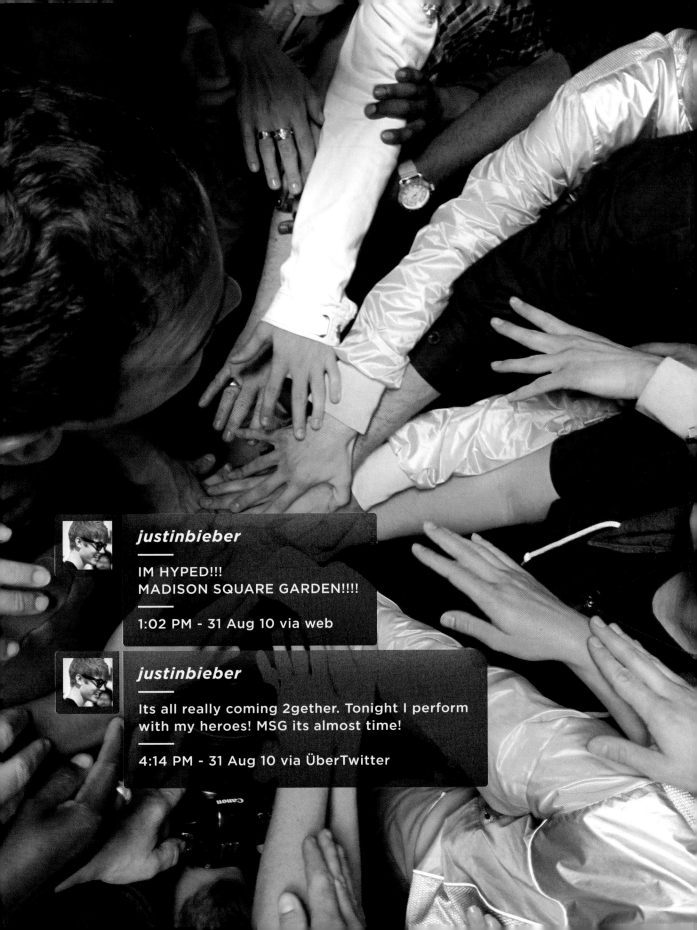

**justinbieber**

IM HYPED!!!
MADISON SQUARE GARDEN!!!!

1:02 PM - 31 Aug 10 via web

**justinbieber**

Its all really coming 2gether. Tonight I perform
with my heroes! MSG its almost time!

4:14 PM - 31 Aug 10 via ÜberTwitter

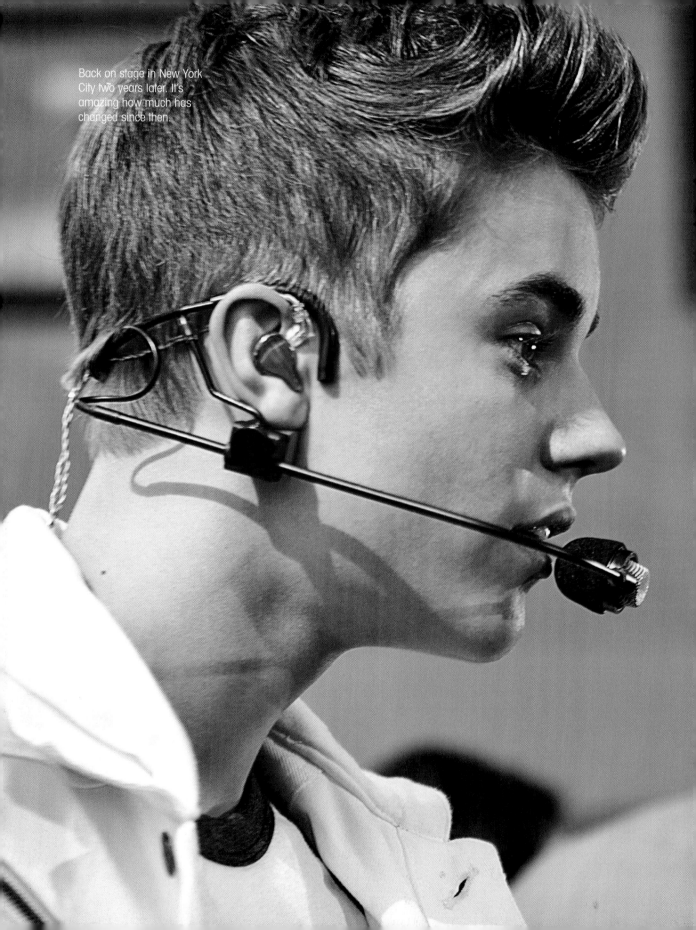

Back on stage in New York City two years later. It's amazing how much has changed since then.

Oh yeah. I smelled a challenge, and I was up to meeting it no matter how hard I had to work to get there.

In my mind, it was all of us against the world, and I knew that if I could sell out the Garden, we would prove that I could stand with anybody. So yeah, even though I knew it was lofty, our goal was to pull that off.

To all of our surprise, it was exactly one year later that Scooter came to me with the news that we had sold out our first U.S. tour in two days and Madison Square Garden in 22 minutes.

My first reaction was, "What?"

Even though I had worked so hard for this, I still couldn't really comprehend what he was telling me. So I asked Scooter, "Is that good?"

"Yeah, kid, that's good—*really* good. Only the greats can sell out an entire tour in two days and only the best of the best can sell out MSG that quickly. I'm proud of you."

Even though we had achieved our goal to sell out the Garden, we never really celebrated our success because selling out the tour—especially the Garden—was only phase one. Now we had the pressure to go on and create a great show that was worthwhile and would give many of my fans great memories of their first live show. This was my first headlining tour and we needed to prove to everyone that I had what it takes to carry my own show so they would want to come back for

the next tour, and the next tour, and the next one after that. This tour was just as much for the fans as it was for any of us.

We kicked off the U.S. tour on June 23, 2010, at the XL Center in Hartford, Connecticut, and did 38 shows before hitting Madison Square Garden on August 31. If you saw the movie *Never Say Never* you pretty much got an inside look at the days leading up to this. And if you haven't seen it, check it out! It's a really good peek at what goes into touring—the fun we have on the road putting the show together and meeting the fans, but also how tough the pressure can be.

With such a heavy touring schedule, my voice had become strained and was getting worse leading up to the New York concert. About a week before that show, my doctors ordered me to rest my voice in between concerts or risk doing it permanent damage. Even though I couldn't talk, I could text, so I was still able to communicate with my fans through Twitter and my team, who were doing the talking for me.

I rarely get scared, but I was a little worried that I wouldn't be at the top of my game on the big night. I want all of my shows to be perfect, but I especially wanted our night at MSG to be special for everyone. There was a lot riding on that show, even if I was the only one who knew the real reason why.

Although I wasn't one hundred percent healthy, my doctors gave me permission to go on anyway. So the night of August 31, 2010, I stood on one of the most iconic stages in the world and said, "What's up, New York City? Welcome to my world. We are gonna have a lot of fun tonight. I got a lot of surprises in store for you guys!" I was really excited to play the Garden and to see so many of my fans who were there to support and embrace this career milestone. I wanted to give them a night they'd never forget, so I definitely had a few surprises planned that I hoped would blow them away.

Some of the biggest stars in the world joined me on stage that night, including Usher, Boyz II Men, Ludacris, Sean Kingston, Jaden Smith, and Miley Cyrus. The Garden show was great and the audience in New York City was amazing. Like Frank Sinatra sings, "If you can make it there, you can make it anywhere." I was so proud that our show was talked about in the New York press and blogs for the next week as one of the most special nights in Garden history. People were blown away. I even had some of my first comparisons in the press to my hero, Michael Jackson. I was pretty much dreaming at this point!

Throughout the tour, I always introduced my song "Never Say Never" by sharing the motto I live by with the audience. "There's gonna be times in your life when people tell you that you can't do something. This is what I tell them: *Never Say Never.*" Those words never meant more to me than they did that night. Madison Square Garden—a landmark moment in my career I will never forget.

# PLAYING FOR THE PRESIDENT

The first time I was asked to sing for President Obama and his family was during a Christmas concert at the White House on December 23, 2009. I sang the great Stevie Wonder song, "Someday at Christmas." It was an incredible honor and one of the only times I can recall being really nervous. If you've ever seen the video, you can tell by my hands, because I didn't know what to do with them. I was like Will Ferrell in *Talladega Nights*! I was also a little worried about my performance because my voice was strained from touring and I didn't know if I would be able to sing. I was literally on vocal rest until the moment I hit the stage.

Now, everyone knows I am pretty spiritual, so I kind of knew in my heart that no matter what, God would be there with me—and He was. Just before I got on stage, my nerves suddenly melted away. I knew in that moment that God heard my prayers and would be with me as I performed. So that night it didn't feel like the President was the only powerful guy listening to me—it felt as if I was singing to God too. Talk about a power crowd! Naw, there wasn't any pressure!

The weirdest thing happened, though. The second I started singing, my voice felt really good. I had sung "Someday at Christmas" in church many times before, so I knew the song cold. At the end, even though my voice had been in pretty bad shape, something just told me I needed to go for this big high note—so I did. I went for it and hit it—the Big Man was with me!

Singing for the President was special, but even better was getting to meet him later that night. While everyone was shaking his hand and being all formal, I said, "What up man?" and dapped him up. Thankfully, he thought it was funny!

I guess the First Family enjoyed my performance because they invited me back to the White House for their annual Easter egg hunt in April 2010. I went with Scooter, my mom, and Kenny Hamilton (my tour manager and former bodyguard). When the Easter egg hunt was done, we were asked if we'd like to hang out at the Oval Office and talk some March Madness with the President. OK, you've got to admit, that's pretty cool! While we were in the Oval Office, Kenny told the President that he had been in the Navy and asked if he could get his own photo with him. As they took a picture together, the President thanked Kenny for his service to the country. Kenny actually cried as he walked out of the office that day—tears filled with pride and appreciation for the President's gratitude.

President Obama is a really nice guy, and after that exchange, I could see why he is so special to so many people.

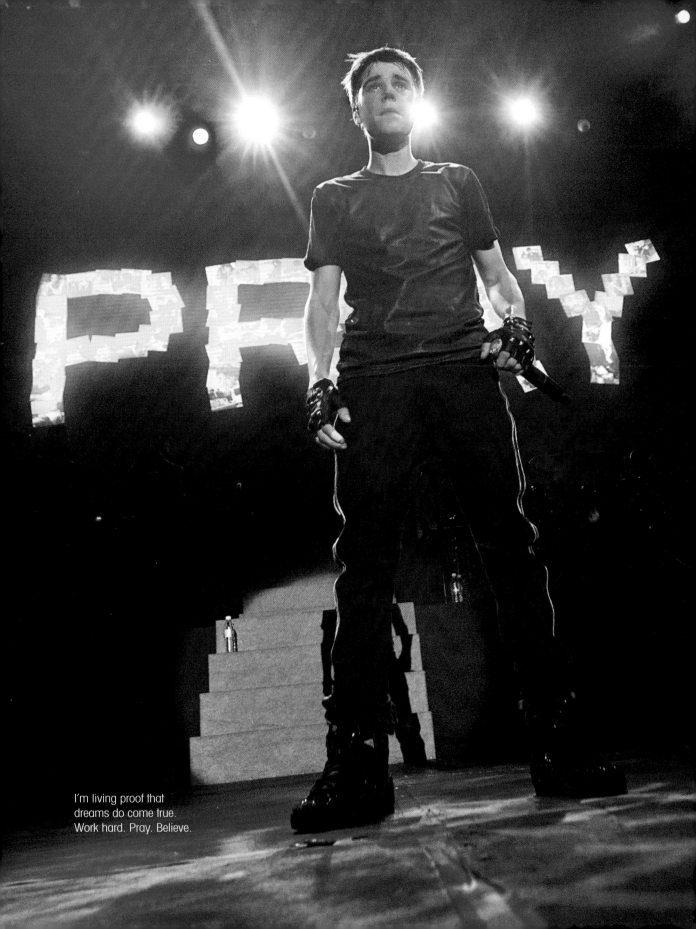

I'm living proof that dreams do come true. Work hard. Pray. Believe.

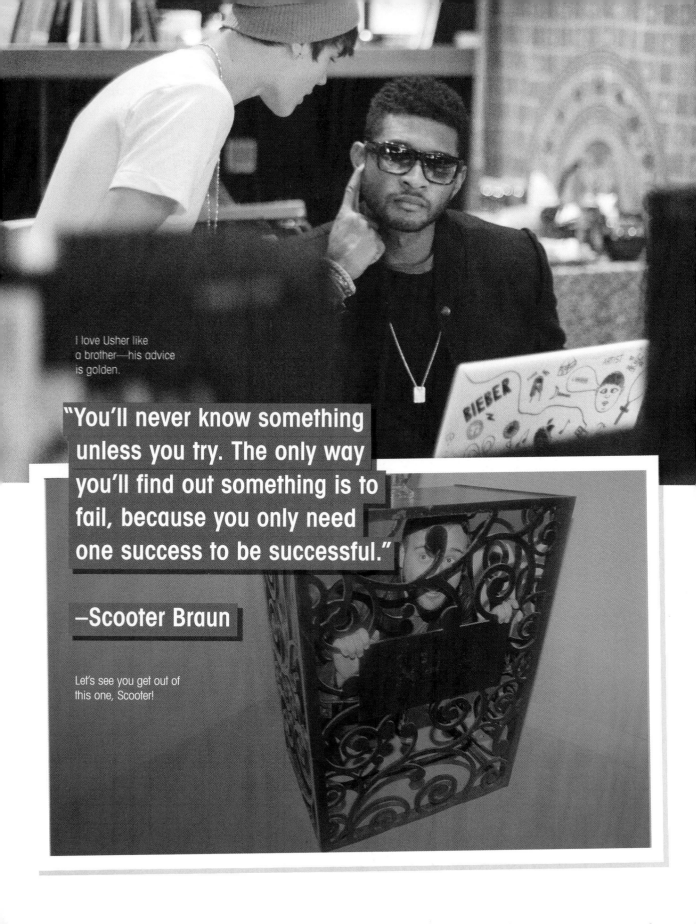

I love Usher like
a brother—his advice
is golden.

"You'll never know something
unless you try. The only way
you'll find out something is to
fail, because you only need
one success to be successful."

—Scooter Braun

Let's see you get out of
this one, Scooter!

# BAND OF BROTHERS

Scooter believed in me from the start. Whenever I started feeling doubt or uncertainty about whether we were going to make things happen, he'd assure me we would. He'd say,

> "The only thing that can stop you is *you*. People who fail in this business, the really talented people, it's never because of their music—it's about their personal lives. Stay focused and never mind any of the crap anyone else says. That's not you—that's them. That's the negative place they want to live in. You choose to live in a positive place. Nothing great ever comes easy."

Scooter has taught me a lot over the years. His advice has helped keep my aim focused and my drive to succeed clear. He's smart and experienced in ways I was too young to understand. Sometimes he's on me so much it can be really annoying; however, I know he only wants the best for me. As I've gotten older, I realize his wisdom has made a definite impact. I've also been lucky that the people who are around me every day are super level-headed and don't just "Yes" me to death. I would hate that because I want the benefit of learning from everyone else's mistakes. Besides, I have the best team in the world, and that didn't happen by accident.

My relationship with Usher is like I'm his little brother. When we are in the studio together and Usher goes into the booth, I pretty much go into awe mode. Usher and I cut a duet together for *Under the Mistletoe* called "The Christmas Song," and, being the competitive guy I am, I want to hit the big runs like he does. It's the first time we've recorded a song together since my voice changed, but even though he is one of my musical heroes, I had no intention of letting him show me up, so I pushed myself hard to hit those big runs and light it up with lots of falsetto. When I hear him sing and see what he can do, though, it's always a reminder of why I look up to Usher as my mentor and why I will always be an Usher fan to my core. But I'm lucky to say that he's an even better friend to me than he is a mentor. He is truly the real deal.

In a way, it feels like I have a lot of older brothers and sisters who are all there to body check me when I start skating outside the lines. Scooter, Usher, Kenny, Fredo, Allison, Ryan, Matrix, Scrappy, Moshe (my bodyguard), Mike, and Dan have all been there, done that—which makes it impossible for me to screw up too badly. We sometimes argue, but at the end of the day, I know each and every one of those dudes has my back and I've got theirs.

We are a family built on loyalty and trust— a true band of brothers.

"I credit Justin's mom Pattie for being so protective of her son from the start. She is a woman of faith. I know that when they started in this, she prayed and she still prays a lot about the team of people that are around Justin. What you see in the people around Justin are actual answers to her ultimate prayer of having Justin surrounded by people that love him and protect him. I'm not saying that it is always going to be perfect around him but for the people he spends the most time with, her prayers have been answered."

—Kuk Harrell, Vocal Producer

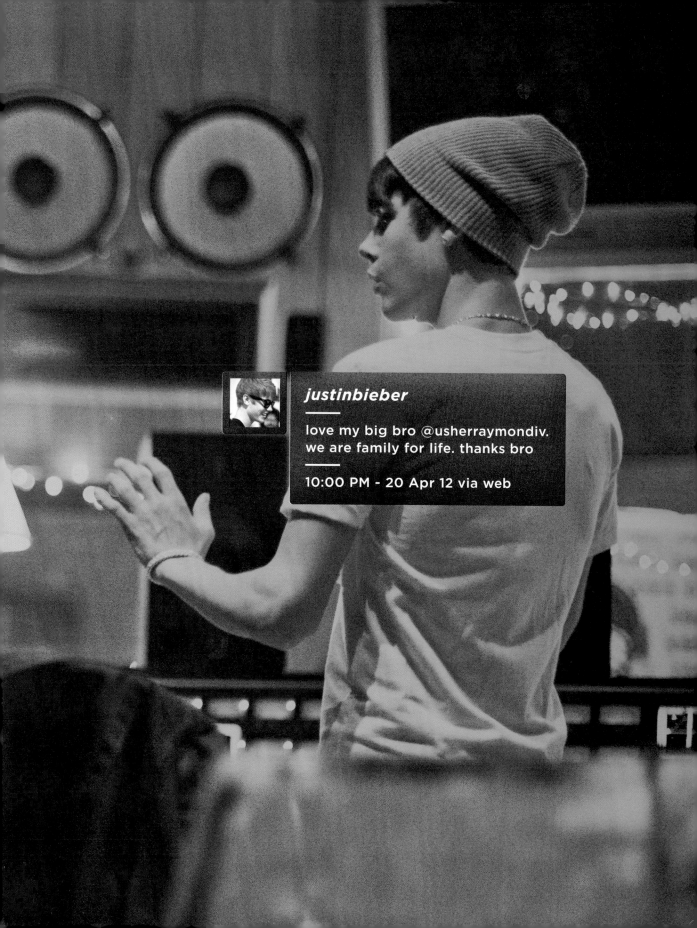

**justinbieber**
_____

love my big bro @usherraymondiv.
we are family for life. thanks bro

10:00 PM - 20 Apr 12 via web

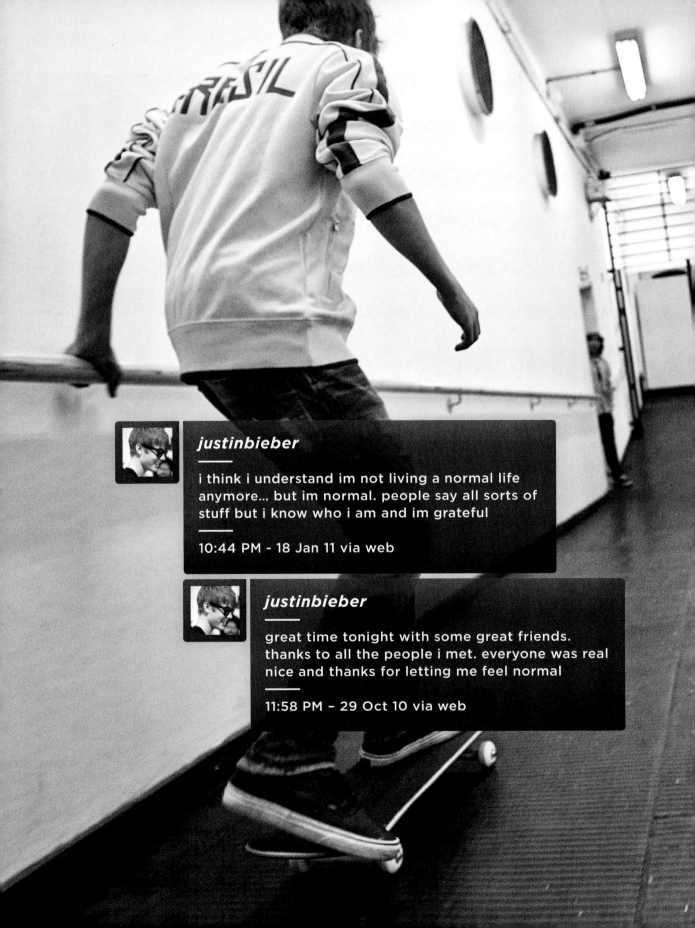

**justinbieber**

i think i understand im not living a normal life anymore... but im normal. people say all sorts of stuff but i know who i am and im grateful

10:44 PM - 18 Jan 11 via web

**justinbieber**

great time tonight with some great friends. thanks to all the people i met. everyone was real nice and thanks for letting me feel normal

11:58 PM – 29 Oct 10 via web

# KEEPING IT REAL

**Memphis, Tennessee**
**July 31, 2010**

I'd been on the road for the first leg of the North American *My World* tour for a little over a month when my friends Ryan and Chaz came to visit from Stratford. Scooter stopped by my hotel room and caught me looking out the window down below to the parking lot.

"What's up with you? You look like the saddest guy in the world!"

"Ryan and Chaz are out there skateboarding," I said, and then turned back around to look out the window at them as they casually enjoyed their boards with thousands of my fans sitting outside the hotel, oblivious to them. You see, my buddies had a freedom I no longer had. All I wanted was to do something normal and skateboard with the guys, but I knew that if I went downstairs to join them it would create total chaos.

"Do you want to go skateboard?" Scooter asked.

"Yeah. But I understand." I knew Scooter could tell I was bummed but I got it—sort of. Being a normal kid wasn't really in the cards for me anymore. I was trying to show the maturity to know better and that I'd come to terms with it. Still, it sucked feeling like I was in a goldfish bowl while my friends were down there.

Scooter didn't like seeing me like this. "C'mon. Grab your skateboard. You are going skateboarding!"

"What?" I thought he was half joking. There was no way I could go downstairs without complete pandemonium. But Scooter insisted. "You are going skateboarding. Trust me," he said.

Scooter seemed to have a plan so I was with it. I grabbed my skateboard, with the biggest grin across my face as we made our way downstairs.

"Wait here." Scooter held his hand up for me to stay back and chill while he went out to talk to the crowd. Just catching a glimpse of Scooter was enough to get them a little excited. Almost everyone around me has become sort of famous, so when fans see my buddy Alfredo (aka Fredo), my musical director Dan, Kenny, Scooter, Allison, or anyone else from my team, they go nuts. It's kind of crazy, but in a way it's good because it takes a little of the pressure off of me.

> # "I have the most incredible fans in the world—and I'm grateful for each and every one."

Scooter began to talk to the kids like friends instead of fans. Scooter knows them and they know him, so if he asks for something, most of the time, we can make it happen. Sometimes they get so loud that they can't hear what he is trying to say. On this particular night though, they were especially cool.

"I want you to listen. See those guys over there? They are Justin's buddies, Ryan and Chaz. Justin was upstairs and he thought that he couldn't be normal and come down and skateboard. We know you guys respect him enough to give him this moment and share it with him. That is more special than anything. I want to make an agreement with you guys. He is going to come down here and at the right moment we will come over and Justin will do a big group picture with you guys. And we will share something special that a lot of fans have never had. You will get to see him be normal with his friends for one night. We are not going to yell at him and take pictures. We are not going to ask for autographs. We are going to let him be a normal kid for one night. Is it a deal?"

And just like that, they said that it was a deal.

As soon as Scooter started to walk away one of my fans yelled out, "Tell Justin that we want him to be normal."

I walked out and said, "I heard that. Thank you. Tonight, I am just going to be normal. I really appreciate it." And I did—big time.

I skateboarded for about an hour and a half. Literally, all of the fans sat down on the pavement and watched me without a fuss or a scene.

As promised, when I was done, I walked over and took pictures in groups of ten with all of them. I have the most incredible fans in the world—and I am grateful for each and every one. As we took picture after picture, I thanked them and then went back upstairs to get ready for our show. There is a funny thing about this story, though. When my fans don't surround the hotels, I actually do get upset because knowing that they're there gives me comfort. And who knows, maybe more stories like this can take place with you! Thanks!

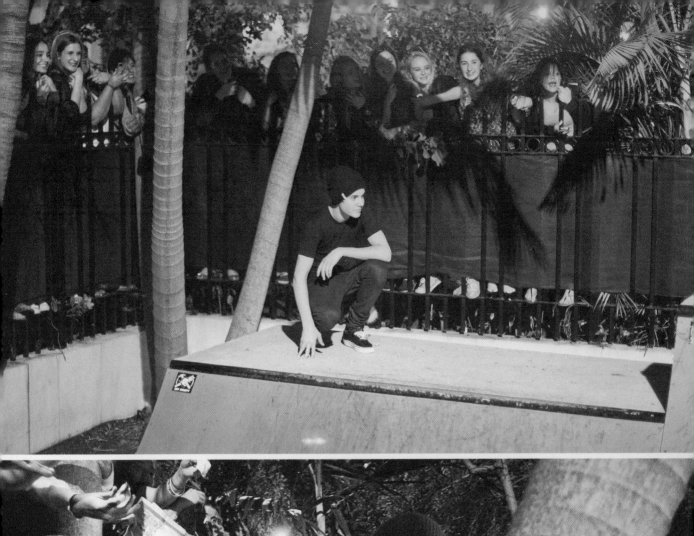

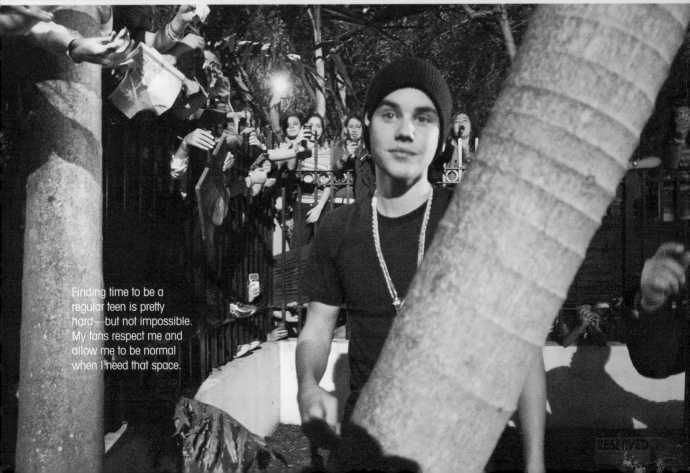

Finding time to be a regular teen is pretty hard—but not impossible. My fans respect me and allow me to be normal when I need that space.

# DECISION TIME

Orlando, Florida
August 4, 2010

## SCOOTER:

Justin was acting a little funky before his show in Orlando—I knew something was off, but I didn't know what. He and I got into an argument, something we rarely do, especially right before he goes on stage. I can't even remember what it was about, but I know it wasn't anything of substance. One of my buddies was there when it happened and overheard the exchange. "Man, are you sure you want to yell at him like that just before he hits the stage?"

"You don't understand. When Justin hits the stage, he flips a switch—so anything that happens before will not affect him." I was positive of what I was saying so I wasn't worried our words would impact his performance that night.

Sure enough, Justin put on an amazing show. My friend couldn't believe that he had been so angry with me and then let it disappear the moment he walked on stage. It didn't surprise me at all. The kid is a born performer. When he is on stage, he's all in. When he steps off the stage, the adrenaline stays high for a little while but he eventually gets back to being a normal teenager. Admittedly, I was bugged by our exchange before the show and wanted to know what was up with him. So when the concert was over, I looked at Justin and said, "Team meeting."

"Why?"

"You know why."

I pulled everyone who was relevant into a private room, looked at Justin and simply said, "What's up? You are acting weird. What is wrong with you?"

That's when Justin did something I've rarely seen him do. He broke down and started to cry.

I cleared the room. It was obvious we needed some quality one-on-one time to have a serious talk. Justin sat down and told me he didn't like being famous and couldn't handle the pressure anymore. He talked about how he can't go out and do stuff because there are always thousands of kids outside his hotel. Everywhere he goes people are in his face. He explained that on one hand, he loves seeing everyone because he knows they care about him but at the time, he was also a self-conscious 16-year-old who just wanted to be normal. He was doing his best to express how he was feeling and I was doing my best to really hear him out so he felt safe, secure and acknowledged.

When Justin finished, I took a deep breath and said, "There are two options here—we can do the teenage pop star thing with no long-term career plan and we can ride this thing for a few years and your career will be done—and I mean *over*—or we can stick on our current plan, which is following in the creative footsteps of Michael Jackson, to build a long-term career that gives you a shot at something that only he has done, which is a career that will stand the test of time.

If you want the Michael Jackson career, you have to grasp that you are never going to be normal again. This is never going to go away and you have to come to terms with the fact that the world is now a part of your life and you are just as much a part of them as they are a part of you. I can't make the decision for you, kid. You need to decide now what you want this to be."

Justin was very quiet. Maybe a little too quiet. But then he looked at me and said, "I want to meet Kobe Bryant."

I was a little taken aback by that response.

"Out of everything I thought you would say, that is the last thing I expected! Why do you want to meet Kobe Bryant?"

"Because I feel he has chased Michael Jordan's ghost his entire career and no matter what he does, people will never say that he was as good as Michael Jordan. And I want to know how he handles that. And I want to know if it is worth it."

Admittedly, he had a point. So I agreed and said, "OK, I am going to set you up to meet Kobe Bryant."

Just before we left for the hotel I looked at him and said, "Regardless of your decision, I made a promise to you when you were 13 years old."

"I know."

I had Justin stand in front of me so I could look him right in the eyes.

"I will always have your back, but I am also going to push you to be the best that you can be as long as you want it."

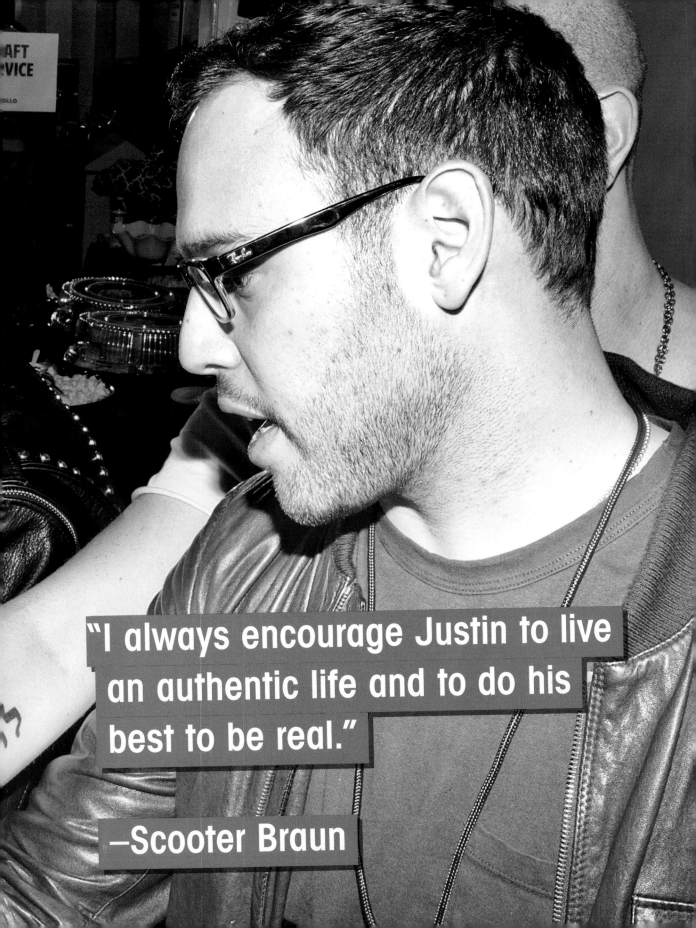

"I always encourage Justin to live an authentic life and to do his best to be real."

—Scooter Braun

He looked at me as sincere as I've ever seen him and said, "I am cool and I want it. I understand, but it is just hard sometimes."

And you know what? He was right. It is hard sometimes, but life is hard and the best things worth having in life take a lot of hard work, determination, and perseverance.

Justin and I stayed at the arena talking until 1:30 in the morning. We eventually hugged it out, like we always do when things get to this place.  By the time we were ready to leave, all the cars were gone except this one local guy who had an old beat-up Toyota. There were still some kids waiting for Justin outside the arena. We figured they'd never know it was him in that old Toyota, so we put him in the back seat and made our way to the hotel.

Ever since that night, whenever things get tough, we talk about Orlando. He has never brought it up again like that but there are times I can tell those feelings are beginning to surface for him.

For the most part, Justin has come to terms that this is what his life is and he has learned how to enjoy it. That was a couple of years ago, and these days, he doesn't really know anything else.

That exchange took place pretty early in his career, within our first 30 shows, so I understood his confusion. Everything was new and admittedly a little overwhelming for all of us. Since then Justin has performed in and sold out 180 arenas and stadiums, has performed for the President of the United States and his family three times, has sung to more than a billion people around the world on New Year's Eve and has become a world-famous icon. Even with all of that under his belt, to me he will always be *The Kid*.

I always encourage Justin to live an authentic life and to do his best to be real. I am proud to say that because of his mom and everyone else who has been around him from the start, Justin has had consistency in his life. Every kid, famous or not, needs that, and that is a big element so he can stay pretty normal in a not-normal circumstance.

# MEETING KOBE

Not long after my talk with Scooter in Orlando, as promised, he set up a meeting between Kobe Bryant and me. We met for dinner in LA so I could talk to him about the Michael Jordan thing. It was just the two of us—no one else. When I asked Kobe how he viewed his place in basketball compared to MJ, he started to tell me that it gives him something to shoot for and at the end of his career he hoped people would see what he accomplished along the way. He talked about how he wants to be the best player he can be. He said he can look at someone like Michael Jordan as a role model, but he can't worry about other people's comparisons.

I was blown away by his outlook. I felt connected to every word of what he was saying and wanted to know even more. I was curious, so I asked him about what type of music he listens to to help get him pumped up for games. Kobe looked at me kind of confused.

"When we were at the Olympics D Wade and Lebron listened to music, but I don't understand that. I am an assassin and ready to kill right now." He was kind of intense and then suddenly broke into a big smile.

I *loved* that warrior mentality. Kobe is always on and ready to compete, two traits I think are awesome and aspire to have in my own life.

I'd heard that Kobe knew Michael Jackson so we talked about him for a while too. He told me Michael used to say that he would study the greats, their movement and their songs—everything so he could absorb their knowledge and experience from the past. That philosophy made so much sense and became something I immediately wanted to adopt for myself and my career going forward. "Practice Makes Perfect," but I like to take that saying and change it a little to "Perfect Practice Makes Perfect." If you practice bad methods you'll get bad habits. But if you practice the right way with the right mentors you can become great.

For the first time, I think I understood that I will never be normal again. I can't have normalcy in my life, but I don't have to get crazy about it. A lot of people count on me, so I have to choose what to do and what not to do. My sanity is just as important as my craft. I want to grow up as an artist, as an entertainer, and I want to perfect it along the way. What I got from Kobe that night is that all I can do is strive to be my best, and the rest will come.

Work hard.
Play hard.
Box hard.

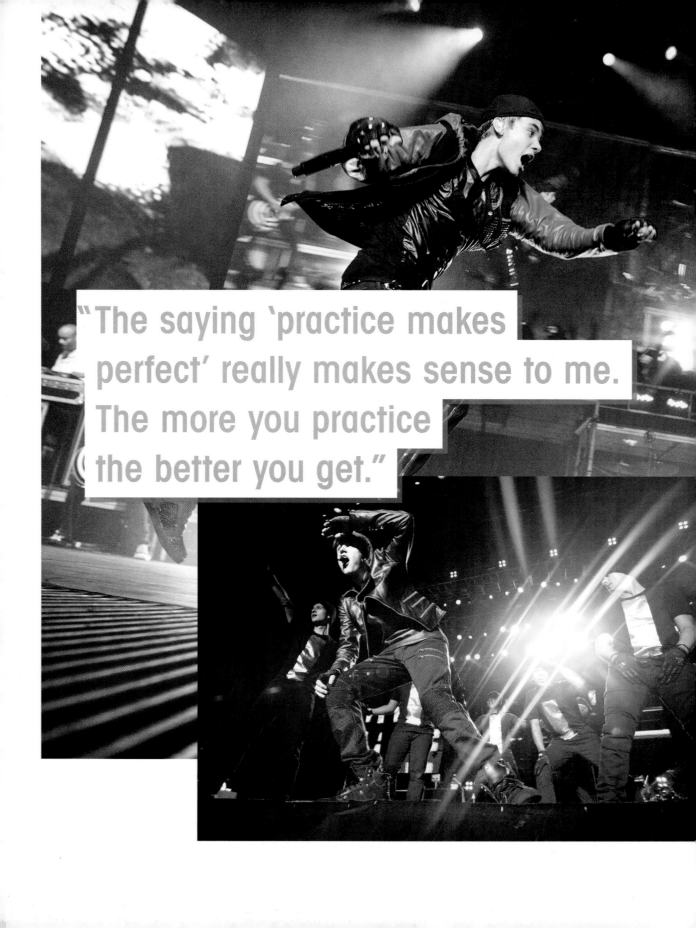

"The saying 'practice makes perfect' really makes sense to me. The more you practice the better you get."

**Before this amazing journey began I'd never set foot outside of Canada. Now I've traveled the world and seen so many amazing things. In that sense, my story is something I like to share with others to show that anything is possible.**

--

Showing my love for Barcelona—
the fans, the soccer, the city.

# CHAPTER 2
# SEEING THE WORLD

## MY WORLD TOUR. 2010–2011

**NORTH AMERICA:**

**UNITED STATES**

| | | |
|---|---|---|
| HARTFORD | ALBANY | **MEXICO** |
| TRENTON | PROVIDENCE | MONTERREY |
| CINCINNATI | NEWARK | MEXICO CITY |
| MILWAUKEE | NEW YORK CITY | |
| MINNEAPOLIS | SYRACUSE | **CANADA** |
| DES MOINES | ESSEX JUNCTION | TORONTO |
| MOLINE | ALLENTOWN | LONDON |
| OMAHA | TIMONIUM | OTTAWA |
| GRAND PRAIRIE | HONOLULU | WINNIPEG |
| TULSA | SACRAMENTO | REGINA |
| BROOMFIELD | ONTARIO | SASKATOON |
| WEST VALLEY | ANAHEIM | EDMONTON |
| EVERETT | SAN JOSE | CALGARY |
| PORTLAND | SAN DIEGO | MONTREAL |
| OAKLAND | OKLAHOMA CITY | |
| RENO | SAN ANTONIO | |
| LOS ANGELES | HOUSTON | |
| LAS VEGAS | ST. LOUIS | |
| GLENDALE | LOUISVILLE | |
| KANSAS CITY | CLEVELAND | |
| NORTH LITTLE ROCK | NORFOLK | |
| MEMPHIS | PHILADELPHIA | |
| LAFAYETTE | BOSTON | |
| ORLANDO | EAST RUTHERFORD | |
| SUNRISE | ATLANTIC CITY | |
| CHARLOTTE | MANCHESTER | |
| DULUTH | PITTSBURGH | |
| NASHVILLE | GREENSBORO | |
| INDIANAPOLIS | GREENVILLE | |
| COLUMBUS | MIAMI | |
| AUBURN HILLS | TAMPA | |
| | BIRMINGHAM | |
| | ATLANTA | |

**SOUTH AMERICA:**

**BRAZIL**
RIO DE JANEIRO
SAO PAULO
PORTO ALEGRE

**ARGENTINA**
BUENOS AIRES

**CHILE**
SANTIAGO

**PERU**
LIMA

**VENEZUELA**
CARACAS

**EUROPE:**

**ENGLAND**
BIRMINGHAM
LIVERPOOL
NEWCASTLE
LONDON
MANCHESTER
SHEFFIELD
NOTTINGHAM

**IRELAND**
DUBLIN

**GERMANY**
OBERHAUSEN
BERLIN

**NETHERLANDS**
ROTTERDAM

**FRANCE**
PARIS

**BELGIUM**
ANTWERP

**DENMARK**
HERNING

**SPAIN**
MADRID
BARCELONA

**SWITZERLAND**
ZÜRICH

**ITALY**
MILAN

**ASIA:**

**SINGAPORE**
KALLANG

**MALAYSIA**
KUALA LUMPUR

**INDONESIA**
BOGOR

**PHILIPPINES**
MANILA

**HONG KONG**
CHEK LAP KOK

**TAIWAN**
TAIPEI

**JAPAN**
OSAKA
TOKYO

**OCEANIA:**

**AUSTRALIA**
BRISBANE
SYDNEY
MELBOURNE
ADELAIDE
PERTH

**MIDDLE EAST:**

**ISRAEL**
TEL AVIV

"I'm incredibly lucky to have traveled the world and have seen so many amazing places, people and cultures. My first world tour was epic—check out all the places we visited—and my next tour is going to be even bigger and better. Watch this space."

# PARIS AND BARCELONA

When we are on tour, Allison usually arranges amazing field trips for us, especially when we are traveling to places all around the world. Instead of reading about things in a textbook, I get to go see them in person. Sometimes that works out, and other times, not so much. Like when we were in Paris—I wanted to check out the Louvre, the Eiffel Tower and walk the famous streets of the city of lights. When we hit the Louvre, however, things got a little crazy. There were thousands of people there for the same reason I was—to check out the legendary pieces of art. But as word spread that I was in the museum, suddenly the *Mona Lisa* seemed like not the only thing to take a picture of. How is it possible that people would be more interested in snapping a picture of me over her? It made no sense to me, but before I knew it there was a crowd of people chasing me through the museum, trying to take my picture. Honestly—I am *not* as interesting as the fantastic collection of art in that museum. Nonetheless, I had to leave because it was getting disruptive for everyone else.

On the other hand, sometimes being me has its privileges. Like when we were in Barcelona, I was invited to play soccer with the Barcelona team during one of their training sessions. Nobody really gets that opportunity. My friend Ryan was with me, who I grew up playing soccer with back in Canada. We were both on the All-Star traveling soccer team as kids, so being asked to play with Barcelona football (that's what they call soccer) team was really exciting and a dream come true for us. They actually let us get on the field and practice with them—even giving me my own custom team jersey. It was really fun and I have to say, we held our own with those guys (well, maybe they let us!). I scored on their goalie, so that was pretty cool. They said that we were the only people that had kicked around with the Barcelona guys all year. It was a really big honor.

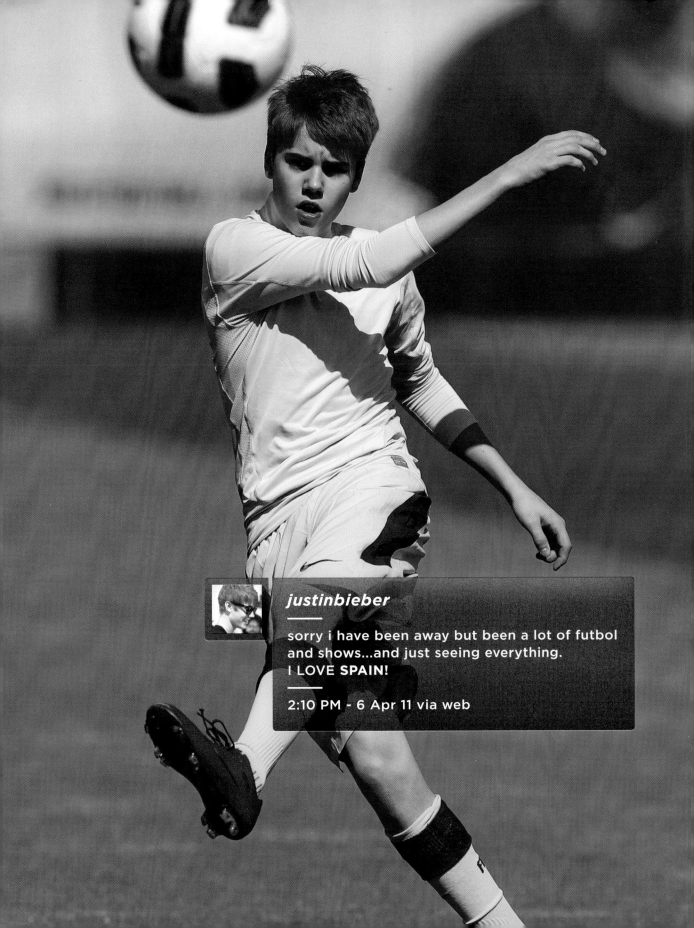

**justinbieber**

sorry i have been away but been a lot of futbol and shows...and just seeing everything.
I LOVE **SPAIN!**

2:10 PM - 6 Apr 11 via web

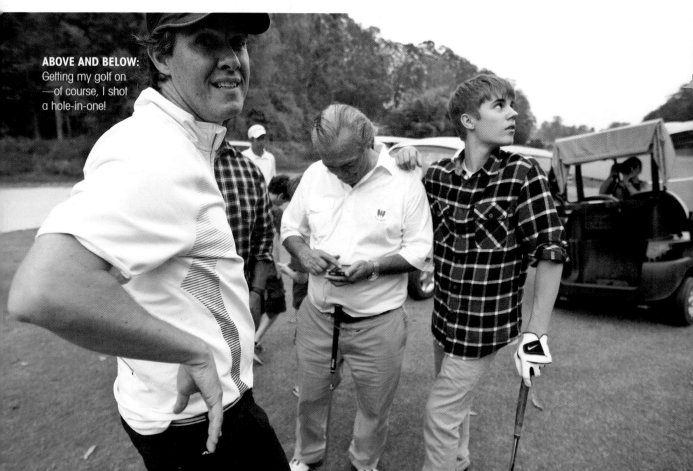

**ABOVE AND BELOW:**
Getting my golf on
—of course, I shot
a hole-in-one!

# BRAZIL

When we were in Sao Paulo, Brazil, a local businessman invited me and some of the crew to play golf on his private home course. Yup. He had his own golf course right in his backyard. It was insane! Each hole was designed to be a replica of his favorite holes from famous courses from around the world. It was a last-minute invitation, so none of us had clubs or proper golf clothes—still, it was a once-in-a-lifetime opportunity so we had to say yes! I kept playing a joke on everyone by loosening up the cords that hold the clubs to the back of the cart, so when they punched their accelerator their bag would fall off. Eventually someone caught on to my trick and loosened mine, which rolled all the way down a big hill. I had to fetch my bag and carry it back to the cart—while everyone laughed.

Hang on, had I just been pranked? Or did the guys just get so fed up with me that I got a dose of my own mischievous ways?

Either way, no one took credit for the bag trick, but I know who you are and you better believe that my revenge will be sweet. Oh yeah, your day is coming! Sweet, sweet revenge will be mine.

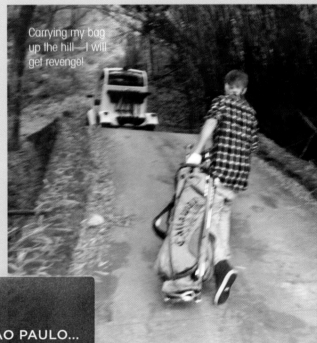

Carrying my bag up the hill—I will get revenge!

**_justinbieber_**

great game of golf this morning in SAO PAULO... now off to the show!! ROUND 2

1:29 PM - 9 Oct 11 via web

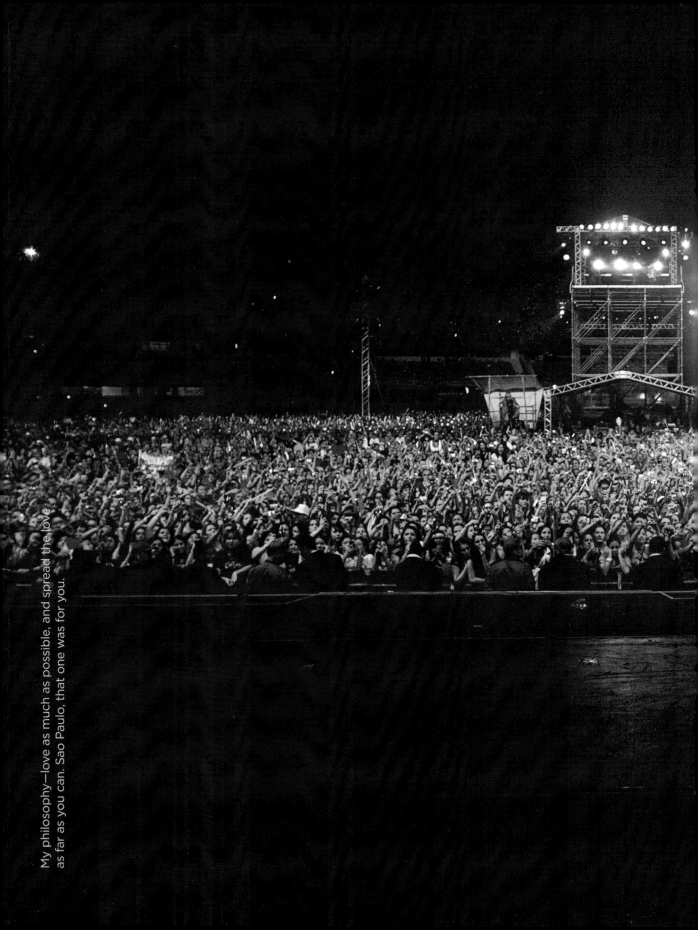

My philosophy—love as much as possible, and spread the love as far as you can. Sao Paulo, that one was for you.

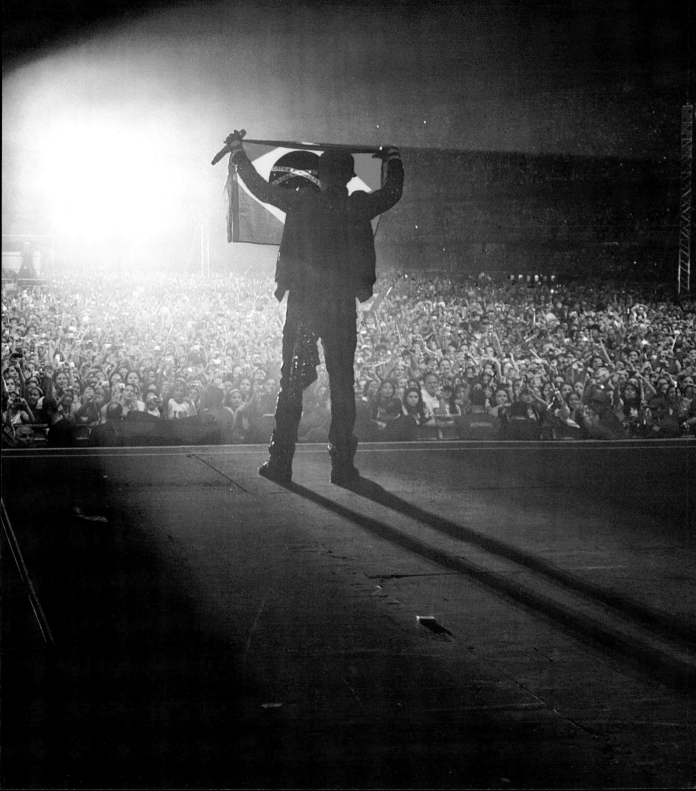

# BIEBERMANIA: LIVERPOOL, ENGLAND

Playing a show in Liverpool was an absolute dream come true for me because it's where the Beatles came from. I was psyched to do the Beatles walking tour around the city, but in the end that wasn't possible.

If America was invaded by Beatlemania in the 1960s then Liverpool got a dose of Biebermania in 2011. The crowds that gathered outside my hotel had grown so big by the time I tried to head out on the Beatles tour, the police actually threatened to arrest my team if they attempted to leave again—so I had no chance of leaving the building. There were too many kids outside for them to control. They simply didn't have the manpower to handle the size of the crowd. They actually had to shut down the streets! It was the craziest thing I had seen during our Europe tour. Things got so intense that security wouldn't even let me out on my balcony! About the only thing I could do was hang in my hotel room and play video games until show time.

The next day, I eventually got permission to keep my promise to visit the Liverpool Children's Hospital. Even though I had prearranged the visit with the hospital, none of the kids knew I was coming, so it was a total surprise to them and super important to do. When I walked through the door, the last person they expected to see was me! Liverpool was unforgettable for many reasons, but most of all for the time I spent at the Children's Hospital that day. It was really special to see their smiles, especially when I gave each of them stuffed animals I had brought along to hand out. Sharing those moments with kids like that really makes my day.

I always try my best to fit in visits to local children's hospitals or meet a kid from the Make-A-Wish foundation. During the North American leg of the tour, I did 86 cities and tried to see a Wish kid at each stop along the way. A couple of hours of my time is just a small gesture I can make to give back to others, something I really love to do. It is sad and sometimes really hard to see so many sick kids, but it is also motivating to see how they don't let their diseases get to them and how strong they are to be in the fight for their lives. Spending time with them is a reminder to me about what's really important in life and how lucky I am to be doing what I love when so many other people will never get that chance.

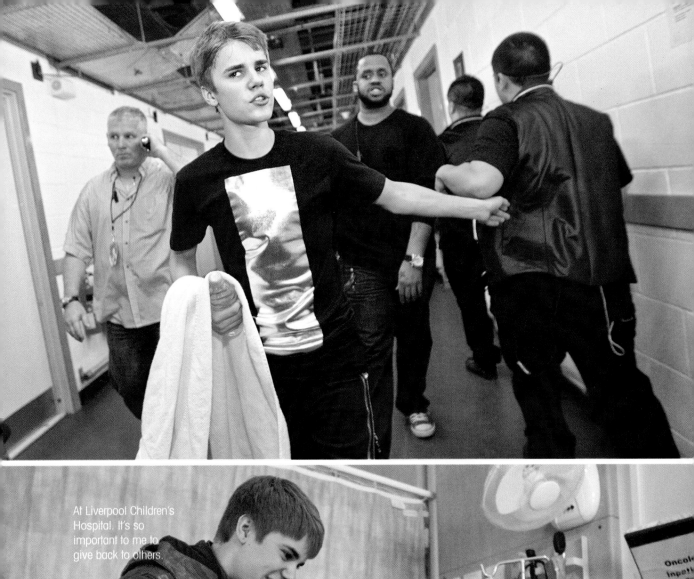

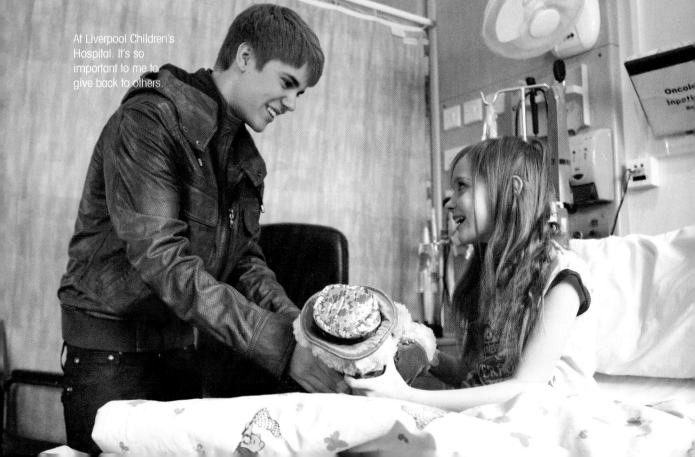

At Liverpool Children's Hospital. It's so important to me to give back to others.

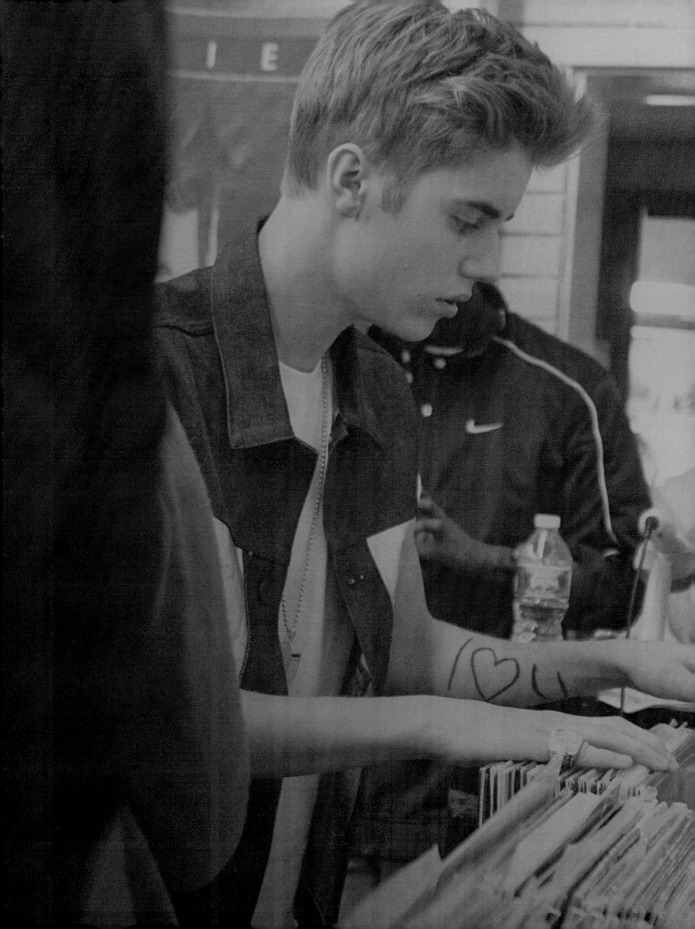

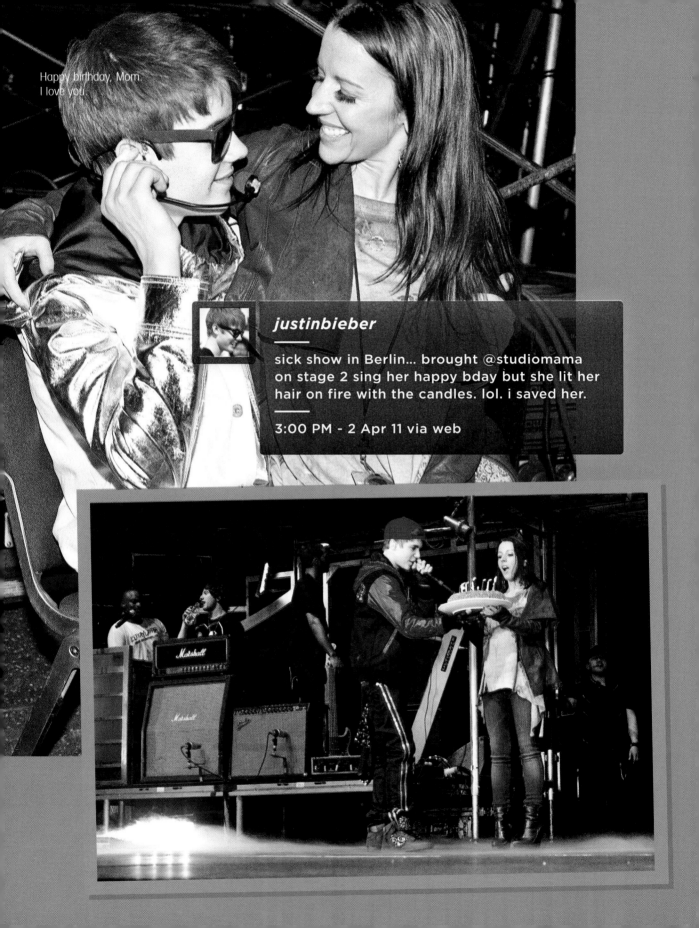

Happy birthday, Mom.
I love you.

*justinbieber*

sick show in Berlin... brought @studiomama
on stage 2 sing her happy bday but she lit her
hair on fire with the candles. lol. i saved her.

3:00 PM - 2 Apr 11 via web

# BERLIN

My show in Berlin was extra special because I wanted to surprise my mom with a birthday cake and give it to her on stage during the show. Allison (who handles my day-to-day management) went out and found an awesome cake that we had ready backstage. My mom wasn't expecting me to acknowledge her birthday during the show, but c'mon, how couldn't I, right? When I stopped the show, I had Kenny bring her out on stage. I could tell she was nervous. She kept asking, "What's going on?" She always acts like she doesn't know what is happening, but let's be real, moms always know what's up!

When she got onto the stage, I had a big cake with candles lit waiting for her so the audience and I could sing her "Happy Birthday." When she leaned forward to blow out her candles, her hair fell into them and caught on fire! The flame quickly burned from the bottom of her hair to the top in a quick *whoosh*. Mom jerked back as I quickly grabbed her hair and put out the flames before we had a potential situation. It all happened so fast that I am not sure she even realized what had occurred until I had already put out the fire. I could tell she was still embarrassed, and by then, she could smell her burnt hair, so I leaned over and said, "Don't worry, Mom. I saved you!"

Later that night I surprised my mom with one more special gift she wasn't expecting.

When I was in the studio recording new music in France, I also recorded the Boyz II Men song "Mama," just for her. My stage manager, Scrappy, was the only other person who knew I had done this. When we finished the recording, he liked the song so much he asked if he could give it to his mom too!

For her birthday this year, I recorded another song to honor my mom called "Turn to You." I released it as a single on Mother's Day 2012 with all proceeds going to charities to help single moms.

# TEL AVIV, ISRAEL

While we were in Israel, my mom and Scooter booked a week off for us so we could see the sights and tour around. It was pretty cool because my dad and Scooter's parents came to join us as well. Even though we all work together, I think it says a lot about our team that we also choose to spend our days off together too. We have experienced so much over the years and in so many incredible places all around the world and have become a very close-knit family.

Being in Jerusalem was especially intense for me because there was so much history and so many events that took place in the Bible and scripture I'd read about in Sunday school and heard my mom talk about in church. I mean, this is the place where Jesus walked the earth! That's pretty big. This was my opportunity to see all of these sacred places and have a personal and private experience with my closest friends and family. Ultimately, I wanted to visit the various historical sites like any other tourist. But, of course, I've had to accept that I am not just like every other tourist, so there were a couple of challenges in making that happen.

Unfortunately, the paparazzi there were extremely aggressive, so there were times I tried to get out and about, but I couldn't get very far, and that made me kind of sad because the experience wasn't what I wanted it to be. Still, I was able to see where Jesus was buried, where he was put on the cross, and where Moses led his people.

My mom knew I was pretty bummed out so she arranged for everyone to rent dune buggies and ride them out in the desert, where there were bouncy trails and, believe it or not, tons of mud. It was awesome! Somehow, we also found a place where we could snowboard outside on artificial snow that was more like fake grass except it was white. Since we couldn't do all of the traditional things we intended to do, we found the most random ways to spend some quality time together and ended up having a really great time anyway.

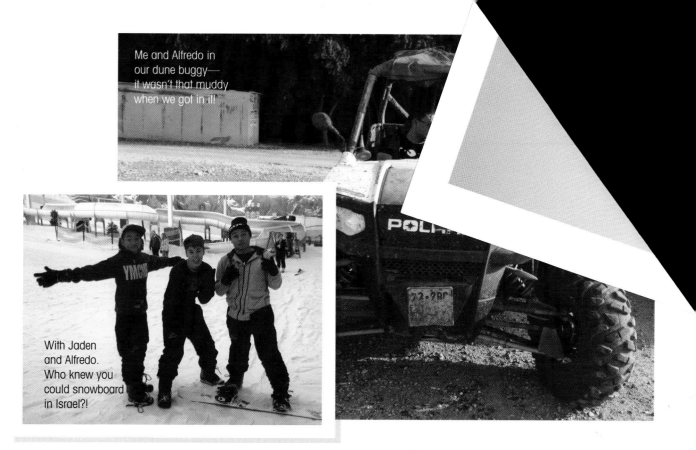

Me and Alfredo in our dune buggy— it wasn't that muddy when we got in it!

With Jaden and Alfredo. Who knew you could snowboard in Israel?!

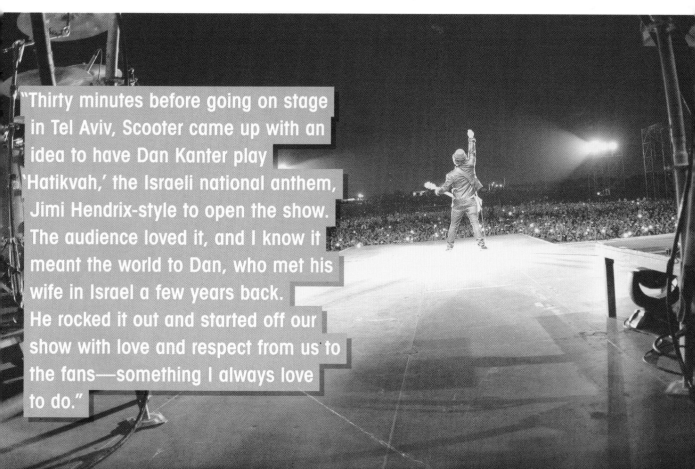

"Thirty minutes before going on stage in Tel Aviv, Scooter came up with an idea to have Dan Kanter play 'Hatikvah,' the Israeli national anthem, Jimi Hendrix-style to open the show. The audience loved it, and I know it meant the world to Dan, who met his wife in Israel a few years back. He rocked it out and started off our show with love and respect from us to the fans—something I always love to do."

With the amazing Will and Willow Smith, powering up before our show in Dublin. That's how we get the party started!

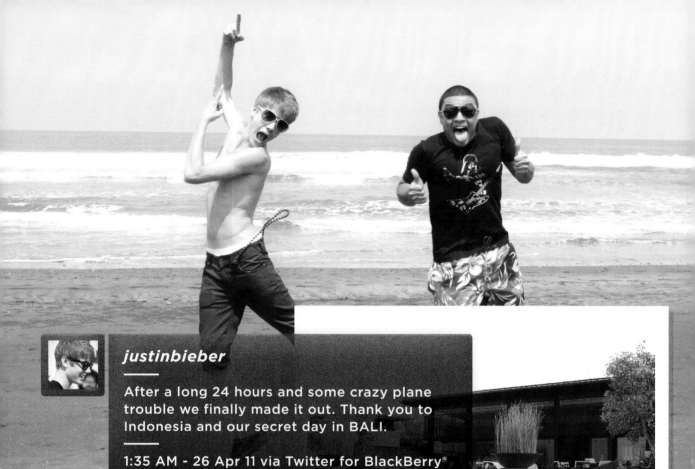

**justinbieber**

After a long 24 hours and some crazy plane trouble we finally made it out. Thank you to Indonesia and our secret day in BALI.

1:35 AM - 26 Apr 11 via Twitter for BlackBerry®

**LEFT:** Channeling my inner Zoolander on the beach in Bali.

# BALI, INDONESIA

While touring in Indonesia in 2011, a local businessman offered his home to the team and me for a couple of days of rest and relaxation after our show there. We were very happy to take this man up on his generous offer, so my mom, Scooter, Carin, Dan, Kenny, Fredo, Moshe, and I headed off to Bali. I have to admit that it was really nice to have a break in the middle of the madness, particularly when we got there and saw this amazing ten-bedroom villa on the most beautiful volcanic beach that was full of black sand. As you know, I love being on a beach anywhere, but Bali was especially sweet because we had the entire villa to ourselves. There were no distractions, no obligations and, best of all, no paparazzi. It was really cool.

The first night we got there, as the waves from the ocean were hitting in front of our place, Dan broke out his guitar and played for hours. We all started to sing along, even making up our own lyrics. Everyone got to do two bars and then had to pass the next two lines off to whoever was sitting to their right. We made up all kinds of hilarious songs together, singing and laughing until 2 or 3 in the morning.

I had the chance to go wakeboarding with Fredo and Moshe, who, despite his insane strength and power, could barely stand up on the board! Fredo managed to get up on the board a couple of times though. The three of us had so much fun.

While we were there, I was inspired to write a song called "Be Alright" with Dan. Dan had been encouraging me to start writing songs that were more personal, you know, about things I know about firsthand and can relate to. He definitely inspired me to go a little deeper with my song writing, and while I was sitting on the most pristine beach I'd ever seen, halfway around the world from home, the song just flowed. "Be Alright" is a song about long-distance relationships— something Dan and I could both really relate to because we spend so much time on the road.

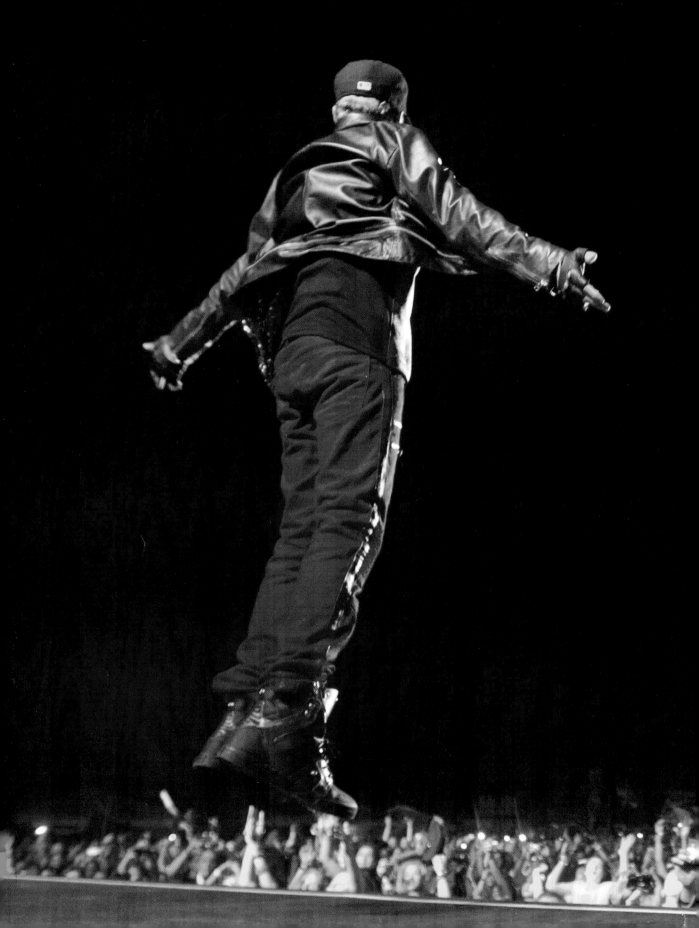

# HONG KONG, CHINA

After my last show in Hong Kong we had a couple of rare days off, so Fredo and I decided to hit the streets and check out the outdoor markets. There's no better way to learn about the culture of another country than putting boots to the ground and exploring how they live. We spent the entire day looking at all of the cool stuff they were selling from food I'd never seen (and would be hesitant to try) to interesting electronic gadgets I could connect to my iPhone, like wide-angle camera lenses and tripods. We spent hours goofing around, having a great time without anyone recognizing me! It was humbling and appreciated because those moments of being a regular tourist are very few and far between for me.

My bodyguard Moshe speaks five languages, however he doesn't speak any of the Asian languages, so we had a translator with us during our stay. While we were kicking around ideas about what to do, our translator suggested we could charter a yacht and spend the day touring the area by water. My mom jumped all over that idea and found a place where we could rent a boat for the day.

Yes! This was going to be an awesome adventure.

When we got to the marina we saw this beautiful boat named *Tara* waiting for us. Fredo, Carin, Ryan, Dan, Kenny, Allison, my mom, and me were all together to enjoy that extraordinary day. As the boat pulled away from the city, its skyline vanished into the horizon. The captain took us to this area where we sailed through caves and lush hilly landscapes. All of a sudden, the captain pushed the throttle all of the way down and we started bombing across the water like we were in a James Bond movie. Everyone's hair was blowing all over the place, especially the girls'. Of course, mine was perfect (ha, ha), but theirs ended up looking like the worst case of bed head I've seen! It was so funny.

When the boat finally slowed down, we came up to a really beautiful private beach that was at the base of these lush hilly canyons. It was so peaceful and the perfect spot to spend the day. We had the entire beach to ourselves. It was awesome. We chilled out, laughed, and enjoyed the absolute peace and beauty of our surroundings. Moments like this are what helps keep me motivated to get back to the stage night after night and leave all I've got out there for all of you. I had the best day with everyone and felt re-energized for our show in Taiwan, the next stop on the tour, and totally hit it hard.

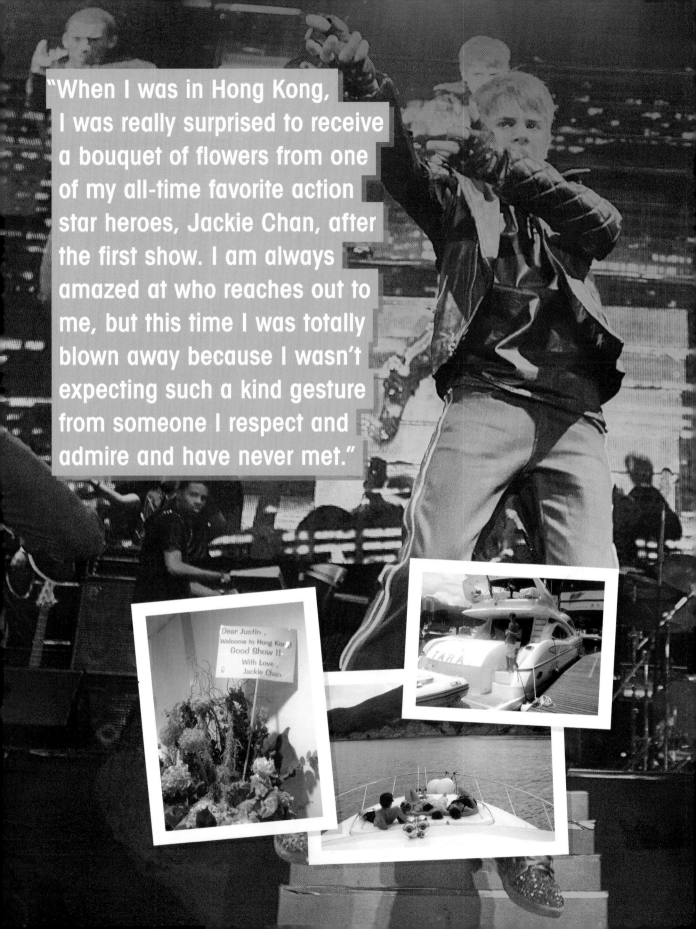

"When I was in Hong Kong, I was really surprised to receive a bouquet of flowers from one of my all-time favorite action star heroes, Jackie Chan, after the first show. I am always amazed at who reaches out to me, but this time I was totally blown away because I wasn't expecting such a kind gesture from someone I respect and admire and have never met."

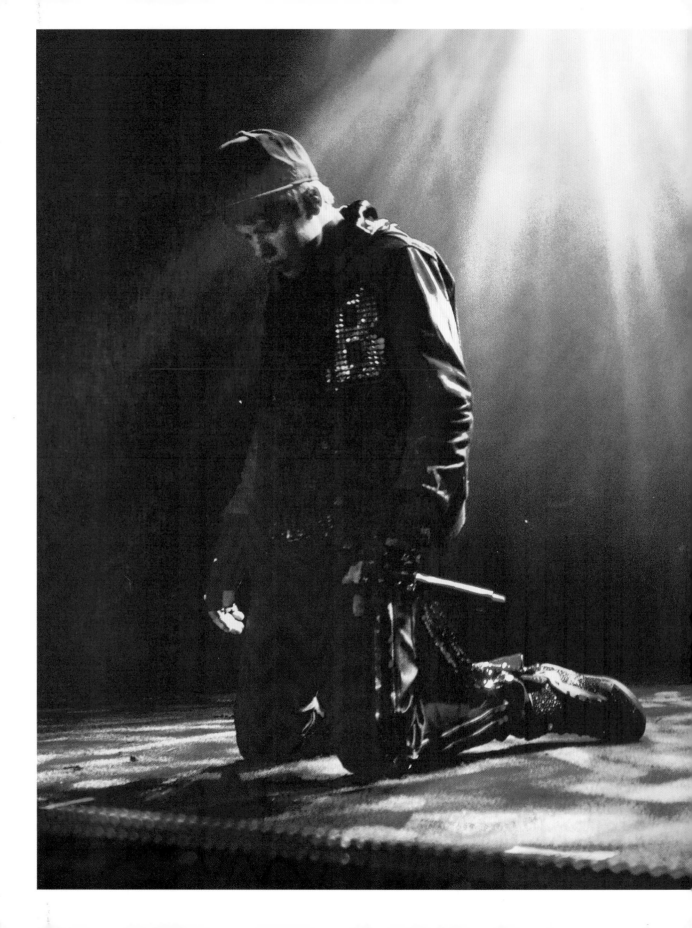

"It feels like I won the lottery. I never thought all this could happen. I'm from a little town in Canada no one's even heard of—that makes it even crazier."

I want to be
successful and be
great at what I do.
I want to be the best.
And in order to do
that, I have to work as
hard as I can, be good
to people and treat
them with respect.
--

Onstage in Barcelona. I'm reaching out
to every one of you.

CHAPTER 3

# IN IT
# TO
# WIN IT

# KING OF PONG

I am a natural competitor. I am a hockey player, basketball player, and soccer player. I was known as an athlete back at my school in Stratford when I was younger and I like to compete. I am not afraid to step up to the competition. Regardless of who or what is in front of me, my goal is always to match or beat it. I am just one of those kids who set their mind on something and make it happen. Whatever I do, I want to be the best. That trait can be annoying, especially when it comes to ping-pong. If you wanna play, bring it!

During our South American tour we started bringing in a ping-pong table to every venue. Secure with my skills, I once offered up a standing bet to anyone on my crew who beats me—and so far no one from the tour has, not even Scooter's dad, who is super competitive, or Scrappy, who is actually pretty good—but not good enough! Ha! It's good to know that if my singing career doesn't work out, I could always tour as a professional ping-pong player.

"If we only do the stuff we're good at, we never learn anything new."

The truth is, I am a really sore loser when someone actually does win a game, first, it's a fluke; second, I will play them again and again until I take back the title and take the next four games in a row just to make it clear I am still the reigning champ. I have to win, or what's the point in playing? I feel that way about everything I do—from my music to shooting pool. If I want to get really good, I'll practice and practice some more until I become the best.

When I first started performing I thought I had some pretty decent dance moves, but compared to the other dancers on the tour, I was still so inexperienced and, yeah, a little awkward. Those guys were sharp, polished and fluid—three things I wanted to be too, so I studied their moves and practiced morning, noon, and night until I got them down. I memorized each of their solos until I had them perfect. And then one day during a rehearsal somewhere on the European tour, I busted out the same moves. I did all their solos spot on. I think I took everyone by surprise. There's no point in doing something if you're not going to strive to be best. My best is still far away—I've got some more striving to do … ha, ha!

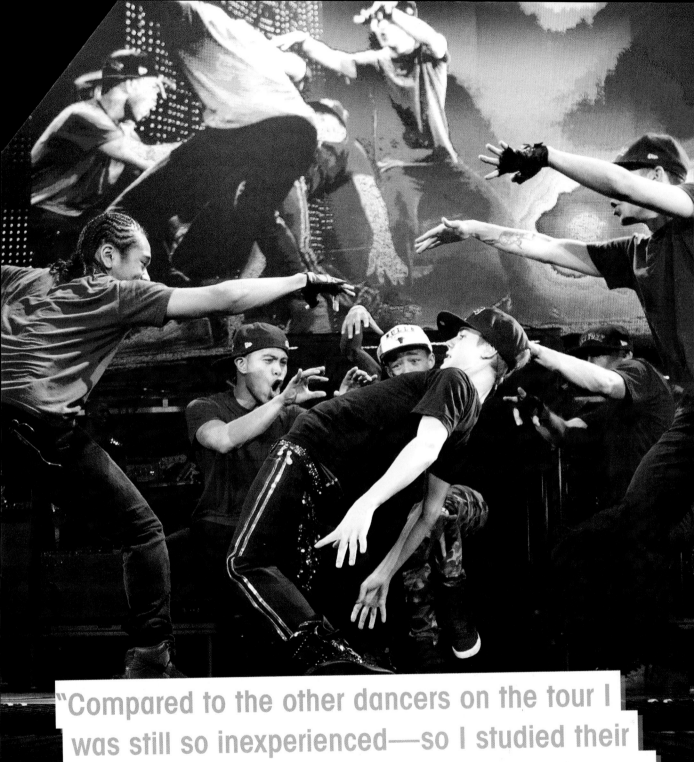

"Compared to the other dancers on the tour I was still so inexperienced—so I studied their moves and practiced morning, noon, and night until I got them down."

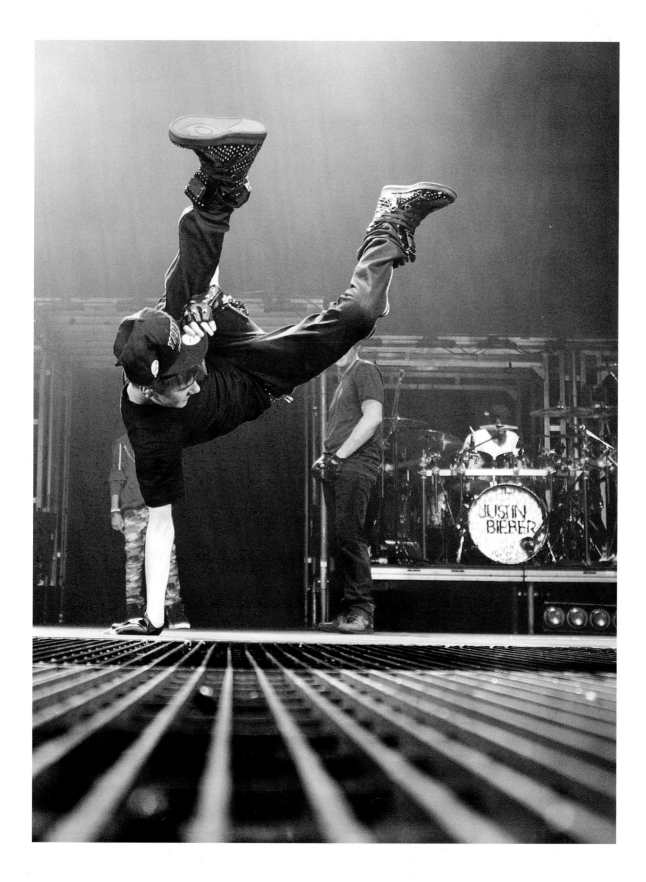

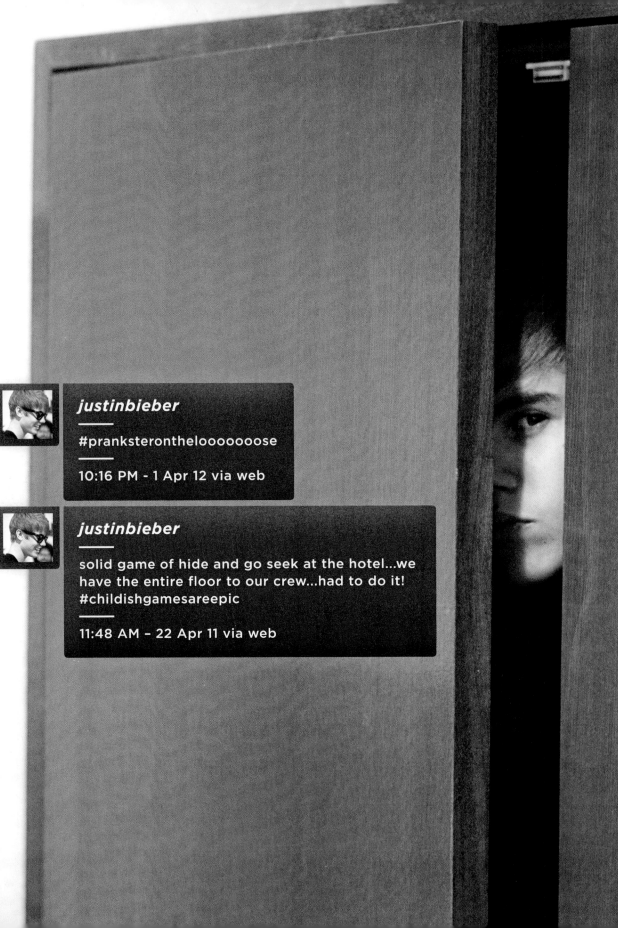

**justinbieber**

#pranksteronthelooooooose

10:16 PM - 1 Apr 12 via web

**justinbieber**

solid game of hide and go seek at the hotel...we have the entire floor to our crew...had to do it! #childishgamesareepic

11:48 AM – 22 Apr 11 via web

# HIDE AND GO SEEK

Unlike a lot of other artists who are older than me, I don't allow any alcohol backstage before, during, or after a show, and for the most part there usually isn't any type of after party or clubbing. We do a show and our normal routine is to head straight back to the hotel so we can all come down from the adrenaline rush of performing. For security reasons, we sometimes have to take a whole floor of a hotel. It doesn't happen a lot, but when it does we often get into epic games of hide and go seek. It's kind of funny because we usually stay in really nice places, so it's pretty unusual to walk down a hallway and see all of the room doors propped open, but it's also really cool because there are a lot of great places to hide on a single floor of a hotel. Sometimes we can even get the hotel management to turn off all of the lights in the hallway so we are playing in total pitch-black darkness. A dark floor in a hotel can actually be a little creepy, but it's so much fun.

Can you keep a secret?

OK, so check this out. What most of the crew doesn't know is that I create alliances with certain people during these games. I will tell my mom or Allison where I am going to hide and use them as diversions. If someone asks them if they've seen me, they'll say "no," or send them in another direction so they can't find me. I already told you, hide and go seek is a game all about survival of the fittest!

> ## "It's important for me to never stop being a kid—even as I get older. At the end of the day, I am just a normal guy."

It's important for me to never stop being a kid—even as I get older. At the end of the day, I am just a normal guy who wants to hang out, play video games and mess around with my friends. With everything going on in my career, I think it's important to stay as grounded as I can—and thankfully my crew goes along with whatever that means—even if they have to endure games of hide and go seek or having to tell me to quit playing a video game I am crushing ten minutes before a show. It isn't unusual for me to be backstage in a fierce NBA 2k12 battle as the countdown clock ticks away on stage, building up the excitement for 40,000 screaming fans. Scrappy will often come to my dressing room to get me mic'd up and I will tell him I can't until I finish the game. Of course, it's always in the middle of a game. Classic teenager stuff.

As I've gotten older, there have been times I have wanted to go out after a show and do something fun with the crew, so sometimes we might go bowling or somewhere like that. When we were in Brazil I wanted to surprise everyone with an after party. It was toward the end of the world tour, so I thought it would be really nice for everyone to kick it. Since I am still too young to get into a nightclub on my own, I thought it might be cool if we rented out a club and invited "the family" to join me. Everyone enjoyed the opportunity to blow off a little steam, and Brazil seemed like the right place to help make that happen.

"Becoming a star didn't seem possible. It was like going to the moon or winning the lottery—you don't even dream of it happening."

# My Christmas album went double platinum worldwide. Christmas albums don't do that, yet it still wasn't good enough for me. Because as someone who is as competitive as I am, there's always room for improvement.

--

On stage in Berlin. Performing for my fans always feels like Christmas has come early for me.

CHAPTER 4

# THE BEST GIFT

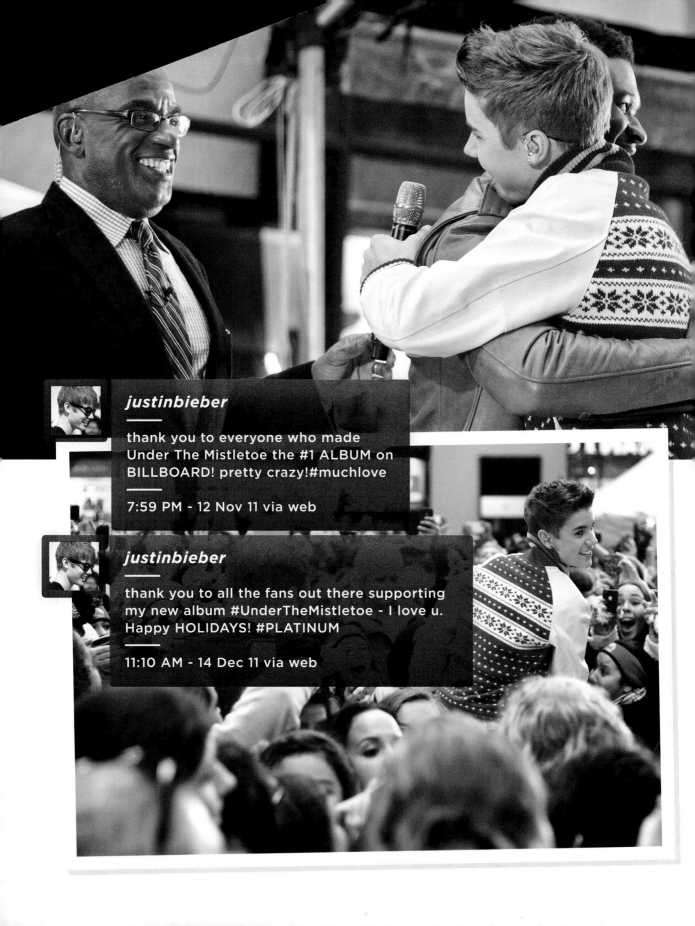

**justinbieber**

thank you to everyone who made Under The Mistletoe the #1 ALBUM on BILLBOARD! pretty crazy!#muchlove

7:59 PM - 12 Nov 11 via web

**justinbieber**

thank you to all the fans out there supporting my new album #UnderTheMistletoe - I love u. Happy HOLIDAYS! #PLATINUM

11:10 AM - 14 Dec 11 via web

# UNDER THE MISTLETOE

When the idea of doing a Christmas album first came up, I don't think anyone on my team thought it would explode the way *Under the Mistletoe* did. Well, at least I didn't think it would. We had planned on doing a small EP first and then just a Christmas single, but when I started writing all of the songs, we realized we had an incredible body of work—enough songs to fill a full-length, 14-song album—so we went for it. I knew I wanted to do some classics, but mostly I wanted to include my original material.

Once we knew the Christmas album was a definite, we decided to go all out by shooting a bunch of viral videos and a couple of major videos to get the marketing machine started and the fans excited.

That's when we got the call from Mariah Carey, who said she'd heard I was doing a Christmas album and suggested we do a remix of her hit "All I Want for Christmas Is You" as a duet. Receiving that phone call was the most surreal thing ever. Mariah Carey was calling *me*?

#Swaggy!

Of course, I said yes, and once I did, we got Usher and Boyz II Men to hop on board for the album too.

We released *Under the Mistletoe* on November 1, 2011. This album was the first time my fans would hear a difference in my voice from *My World*. Everyone knew my voice was going to change after I went through puberty—what we weren't completely sure of was whether my fans would receive my new sound. But then it occurred to me that my fans are going through puberty too, so why would they flip out? Plus, I believe in my fans, and know they totally support me, so I didn't really think this was a big deal. The album sold 3 million copies worldwide, which shocked everyone. It was the biggest Christmas album in the history of my record label. We had a hunch it was going to do well but we didn't know it was going to be that big. Even though it was a Christmas album, it ended up as one of the biggest-selling albums of the year—an accomplishment I am extremely proud of and grateful to my fans for helping make happen.

# MASSEY HALL

Toronto, Canada
December 21, 2011

Playing Massey Hall in Toronto is something all Canadian artists look forward to doing during their careers. Every great Canadian artist has played there from Neil Young to Celine Dion. The night I played Massey Hall was a homecoming of sorts. It's close to where I grew up so it was like being home. I used to sing on the steps outside the Avon Theater in Stratford, pretending it was Massey Hall, hoping that someday I'd get the chance to be the headline on that famous stage.

Playing Massey Hall was like getting a two-for-one special because Dan is from Toronto, so in a way this show was a homecoming for him too and would likely be one of the most special we'd play so far. I'd been doing stadium and arena shows for months, and although there was a lot of pressure to do the same type of venue that night, I decided to play the Much Music Home for the Holidays Show at Massey Hall because I wanted this particular show to be more personal and the hometown audience to feel special.

Plus, it was my only real chance to share my Christmas record with my Canadian fans, so the whole idea was to do something different as my own way of giving back to them.

In my mind I wanted to change things up a bit from our regular routine. I thought it would be cool to have one night where I wasn't a big pop star playing my usual theatrical show. I just wanted to be the hometown kid who was there to give his audience an intimate acoustic show— just my fans and me joking around, singing songs together. To set the right tone, we had a single piano on stage and two guitars—one for Dan and the other for me. That's it. A show doesn't get more intimate than that.

Even though I'd come up with a loose set list before the show, there was nothing concrete that I had to stick to—something that's pretty unusual for an artist to do. This show was my time to do whatever I wanted and play how I felt.

Since this was a Christmas show, Scrappy dressed as an elf and brought hot chocolate out on stage, looking like one of Santa's helpers! According to him, elves in Canada look different than they do in America. I have no idea what he's talking about!

I was only supposed to play for 45 minutes to an hour, but the vibe in the room was so warm that I stayed on stage for more than two hours! I played whatever came to mind and took requests from the audience, asking, "What do you all want to hear?"

For me the holidays are all about being with family, so I even brought my little sister Jazmyn on stage and we sang our version of "Baby" together. To be honest, I think she stole the show right out from under me that night. You better watch out world—there's another Bieber coming!

All in all Massey Hall was an unforgettable night. It was definitely a one-of-a-kind experience for all of my Canadian fans, friends, and family who came out to share this special appearance with me—and the best way I could think of to close out the Christmas album promo trip and welcome in the holidays.

**justinbieber**

Tonight was special. No rules. Music, family, friends, fans, charity, and music. Thank you. #HomeForTheHolidays

8:37 PM - 21 Dec 11 via UberSocial for BlackBerry®

**justinbieber**

Great day so far. All about #givingback today. #HomeForTheHolidays

1:14 PM - 21 Dec 11 via UberSocial for BlackBerry®

# "That boy's got soul."
# —Stevie Wonder

## THE X FACTOR

**Hollywood, California**
**December 22, 2011**

When I was first asked to appear on the season finale of *The X Factor* in the U.S., the original plan was to perform "All I Want for Christmas Is You," my duet with Mariah Carey that had been recently released. We had shot the video together, but because of other obligations Mariah couldn't get back to LA in time to do the show. We were going to cancel the whole thing but Simon Cowell called Scooter and said, "We really need Justin for the finale. This would mean a lot to me. Can you make it happen?"

Scooter wanted to commit, but only if he could figure out how to make it a big moment for everyone. My agent, Rob Light, also represents Stevie Wonder, so Scooter thought he'd give it a shot. He called Rob and said, "I know Stevie is in town because we are doing his annual House Full of Toys charity event this weekend. Do you think he would do *The X Factor* with Justin?"

Rob called Stevie, who immediately said he was in.

My two musical heroes of all time are Stevie Wonder and Michael Jackson—I could hardly believe I'd get the chance to perform with Stevie. How dope is that?!

When he showed up for rehearsal, he was so chill, like seeing an old friend. "Hey guys, what's going on? It is good to be here." He set up his keyboard in his dressing room and wanted to rehearse because we had never sung together. We decided to sing "The Christmas Song." All during our rehearsal the only thing I could think was,

"Stevie Wonder is singing in front of me, playing the keyboard and doing solos on his harmonica." I mean, c'mon! How much cooler does it get?

We were each taking turns doing our solos when all of a sudden we sat down at the piano together and started playing each other our ideas and riffing on how to do the song. It didn't take us very long to veer into writing original songs together. Stevie actually played me a song he'd written sometime back that he thought might be good for me. I'd been singing Stevie Wonder tunes since I was a little kid and there I was, sitting next to him listening to him sing a song he wrote for me! It was the greatest experience to be with such a legend, jamming and having a really good time.

After we performed live on the show, I was able to share with Stevie Wonder what an honor it was to have him come out and perform with me. Then Stevie said something I will never forget; he said I reminded him of himself when he was a little boy. I cannot think of a higher compliment coming from someone with so much talent. I was overwhelmed by his kindness and generosity. Christmas came a couple of days early for me wrapped up in a package signed, sealed and delivered by the man himself, Mr. Stevie Wonder.

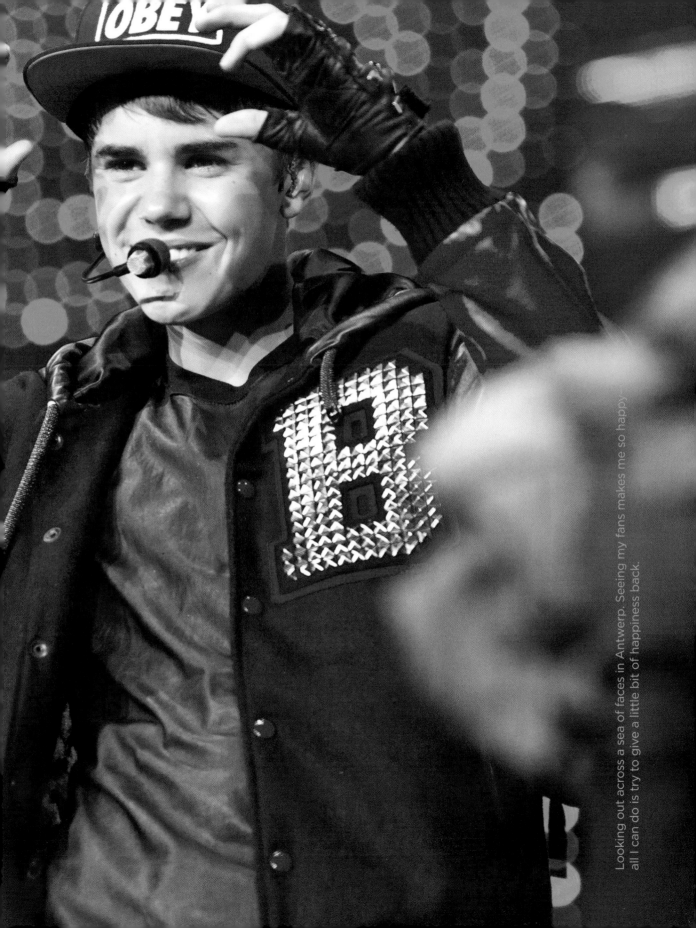

Looking out across a sea of faces in Antwerp. Seeing my fans makes me so happy—all I can do is try to give a little bit of happiness back.

# NEW YEAR'S ROCKIN' EVE

**Times Square**
**New York, New York**
**December 31, 2011**

It was a really big deal when we decided to sing the Beatles' song, "Let It Be," in Times Square for *Dick Clark's New Year's Rockin' Eve.* It was the 40th anniversary of his annual show, which also turned out to be his last, and a real honor to be included. Everyone kept telling me that the most important thing I needed to focus on was not messing up Paul McCartney's lyrics. Scooter, Usher, Dan, and everyone else around me practically beat the lyrics into my head so I wouldn't make a mistake. They were like, "You can't mess up one word." We even watched old footage of Paul McCartney singing the song over and over again. Usher ran rehearsals with me and even took the time to go on YouTube to show me footage of people who had botched the national anthem or messed up Beatles lyrics and all the criticism that they got for their mistakes.

"You have to deliver this," Usher told me over and over.

I worked really hard at getting the song to a place where I felt comfortable enough to make it my own without disrespecting Paul McCartney or any Beatles fans. I had to make sure I had it perfect. I practiced on my little keyboard at my grandma's house back in Stratford until I made sure I knew every single chord and note.

Once I had it down cold, as a musician I wanted to put my own touch on it, so I started working on an original arrangement with my band. I knew exactly where I wanted the band to drop in a certain place and how I wanted the drums to sound. To make it clear, I took the sticks and showed my drummer how I'd play it—and thankfully, the ideas worked.

When it came to the famous guitar solo, I thought it might be fresh to get someone big to play with us, so I asked Scooter to approach Carlos Santana. He was so cool about the invitation, immediately saying yes. It was such an honor and privilege to play with him that night. Right before we hit the stage, Santana turned to Dan and me and said, "I never play a note on my guitar unless I feel everything in my soul." I totally understood what he was saying because I feel exactly the same way. I knew exactly how I wanted the song to sound to the audience that night and I didn't stop tweaking until we got it right.

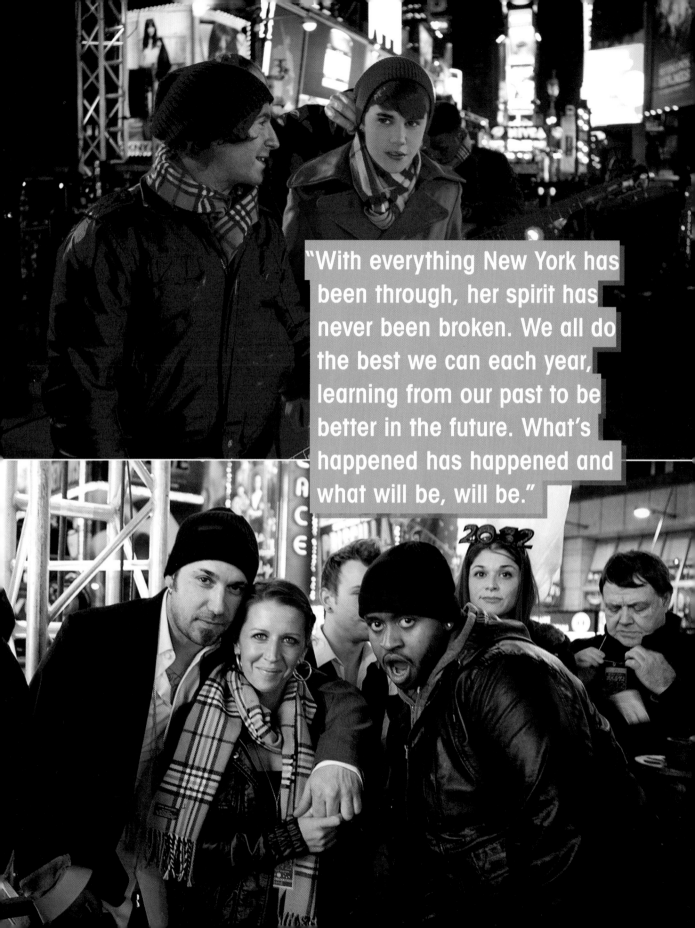

"With everything New York has been through, her spirit has never been broken. We all do the best we can each year, learning from our past to be better in the future. What's happened has happened and what will be, will be."

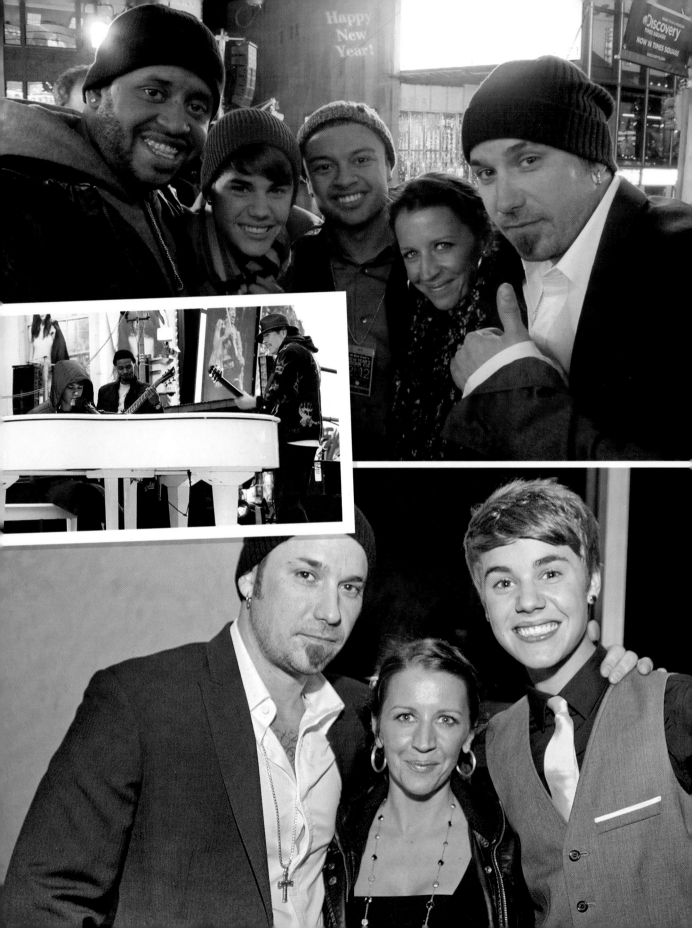

There were over a million people in Times Square to celebrate the New Year and something like a billion people watching all over the world. I am pretty sure this was the biggest show I've ever done—so far. Hmm…a bigger crowd…I'm thinking Super Bowl half-time show, 2013? Hey, a guy can dream, right?

The fans were crazy. It took 25 police officers to move me and the crew through the crowd. We all had to hold hands or someone could easily have got left behind. We had to move in and out of the people so quickly, keeping our heads down, hoping to get to and from the stage without anything going wrong. It was intense, but an unforgettable way to ring in the new year.

It was an incredible performance. I made Usher, Scooter, my parents, my friends and yes, of course Dan (the ultimate Beatles fan) proud. Everyone in Times Square was singing along with me, which was truly moving. Naturally, Santana was incredible—it was one of the best feelings I've ever had.

After I finished that night, I got to go with Ryan Seacrest, Lady Gaga, and the other performers to count down to the famous ball drop in Times Square. Once all of the performances and the ball drop were done, my team threw a big party for me, my friends, family, band, and crew at a loft in New York City. It was the perfect way to start 2012!

**justinbieber**

Performed with Carlos Santana. Honored. #letitbe #happynewyear!

9:15 PM - 31 Dec 11 via Mobile Web

**justinbieber**

New Years is starting all around the world. so to all my fans around the world...THANK YOU FOR 2011 and Have a Great 2012. I LOVE U

12:42 PM - 31 Dec 11 via web

# CHAPTER 5

# SETTING AN EXAMPLE

I want every one of my fans to feel like they're helping out the world in some way. And being the one to influence them to do that, that's something positive I can do with what God's given me

--

At the show in Buenos Aires. This was one of those moments when I definitely felt part of something bigger.

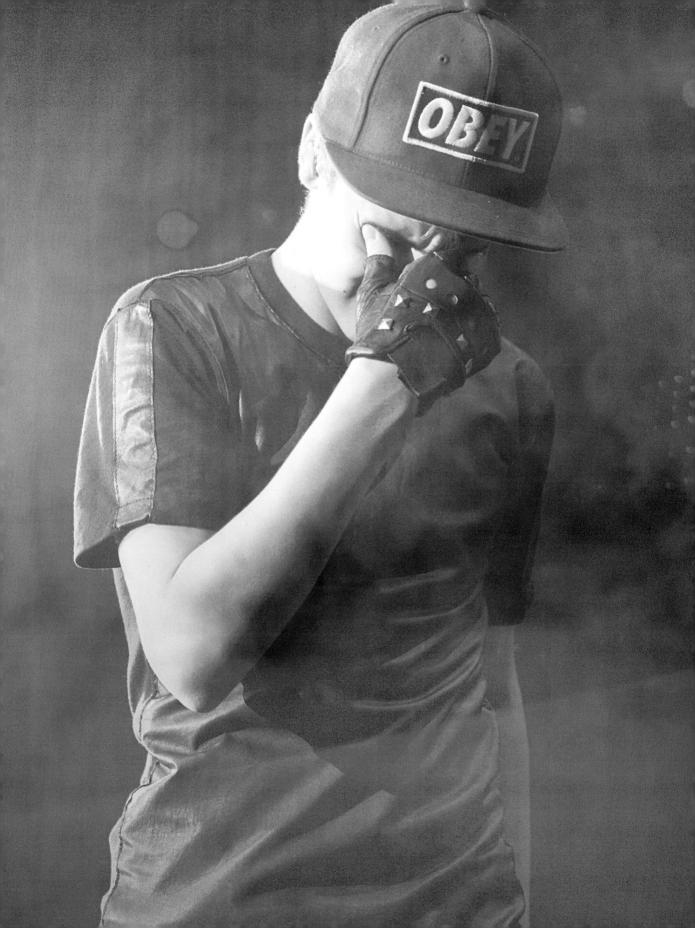

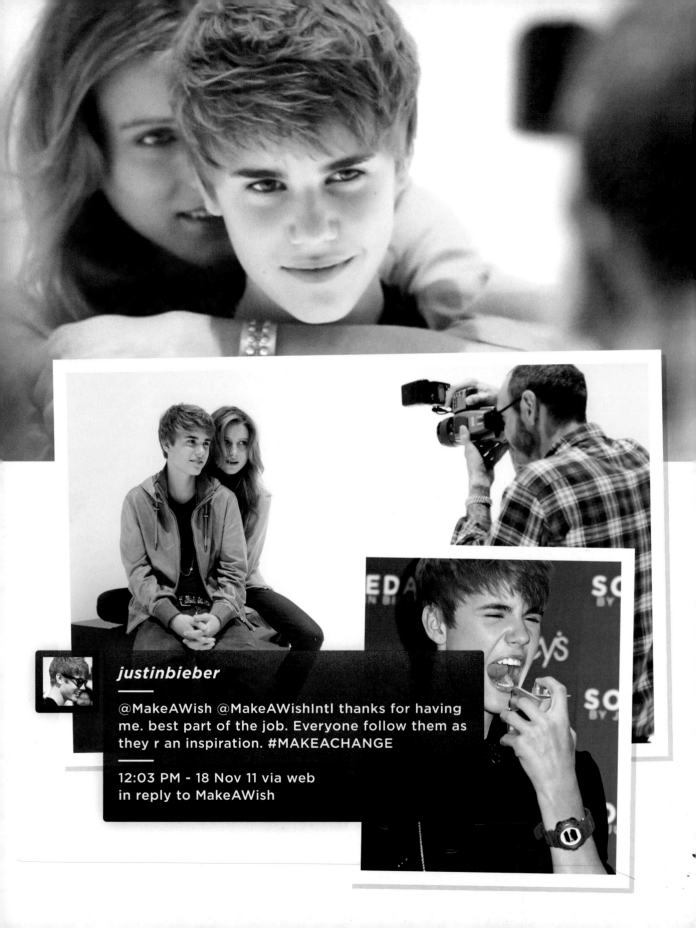

**justinbieber**

@MakeAWish @MakeAWishIntl thanks for having me. best part of the job. Everyone follow them as they r an inspiration. #MAKEACHANGE

12:03 PM - 18 Nov 11 via web
in reply to MakeAWish

# PAY IT
# FORWARD

While shooting a commercial for my fragrance, I had the chance to take a ride in a zero-gravity airplane. I was psyched about the experience but I wanted to share it with my friends, so I asked the producer if Kenny, Ryan, Vanessa, and Allison could come with me. We are all on this journey together, so if I get to do the fun stuff, they do too! We all flew to Las Vegas where the plane was waiting for us at a private airport. When you go up in the plane, you experience three times the normal g-force on your body and you're suddenly weightless. They warned us to go easy the first round and not to do anything too crazy. Of course, I was doing flips and spinning around. It didn't take me long to figure out why they warn you—after 5 passes, I was feeling so nauseous that I was toast.

Although I don't like to make a big thing out of it, every deal I do has to have a charitable component or we don't do it. We give away a portion of all proceeds from my fragrances right down to concert ticket sales—where one dollar of every ticket sold goes to two of my favorite charities: Pencils of Promise and the Make-A-Wish Foundation.

When I was approached about doing a fragrance, I decided to do something different. I know most male artists who do fragrances make cologne for men, but let's be real; the way a girl smells is very important to a guy—especially this guy. I have such a deep connection to my fans, so creating a fragrance that I personally love is another way I could bring them closer into my world. Plus, in working with a company like Give Back Brands, I could use it to do something good for the community. In fact, the chance to give back is one of the main reasons why we created Someday. My team and I not only saw it as an opportunity to give my fans something they would love, but also as a chance to make a difference in the world.

Someday became the bestselling fragrance in the world in 2011 and even won a FiFi Award—the equivalent of winning an Oscar in the world of fragrances. I was also given the Elizabeth Taylor Fragrance Celebrity of the Year Award, which honors a celebrity who has embraced and promoted the world of fragrance. Because of the incredible sales of the fragrance, through Pencils of Promise more than twenty schools were built from the proceeds in the first six months after its release. Since then we've been able to do even greater things to help those in need.

Inspired to keep giving my fans what they want combined with ways to give back, I released my second fragrance in July 2012, called Girlfriend. The name was inspired by "Boyfriend," my first single from *Believe*.

As long as I have the opportunity to do good things for others, I will continue to dedicate myself to doing so. It wasn't so long ago that I was a kid who had to swipe clothing from the school Lost and Found because my family couldn't afford to buy me new things. I used to scoop them and use them. I've never forgotten what that feels like.

In late October 2011, I appeared on *The Ellen DeGeneres Show*, where she did a follow-up piece on the Whitney Elementary School, a nationally renowned school which provides its needy students and families with food, clothing, health services, and the occasional rent check. Ellen originally did a spotlight on the school during her first show of the season and had become an advocate for the great work they do in providing their students with free haircuts, dental care and eye glasses, if they need them. It's where families can get services and supplies they otherwise couldn't afford. It's also a place where parents can go to learn how to read or get help if they fall behind on their rent. If the school didn't feed and clothe the majority of their kids, they'd be out on the streets.

I was so moved by the clip because I instantly related to the kids in the school. While growing up I didn't have a lot, so when I saw those kids and how they were being taken care of by their principal, it was very touching to me. After all, I used to be just like them so I wanted to do whatever I could to help out too. After the piece, Ellen announced that Target was donating $100,000 to the school.

Much to the surprise of everyone around me, I offered to match the $100,000 donation dollar for dollar and promised the kids that I would come to their school to do a special Christmas concert just for them in December. It wasn't planned—I just felt like it was something I wanted to do.

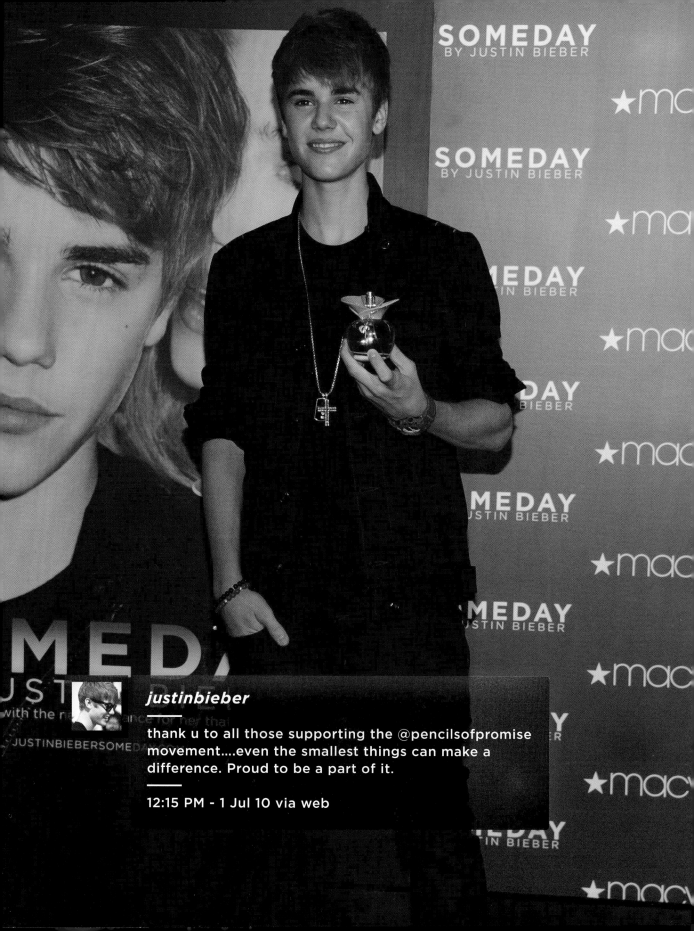

**justinbieber**

thank u to all those supporting the @pencilsofpromise movement....even the smallest things can make a difference. Proud to be a part of it.

12:15 PM - 1 Jul 10 via web

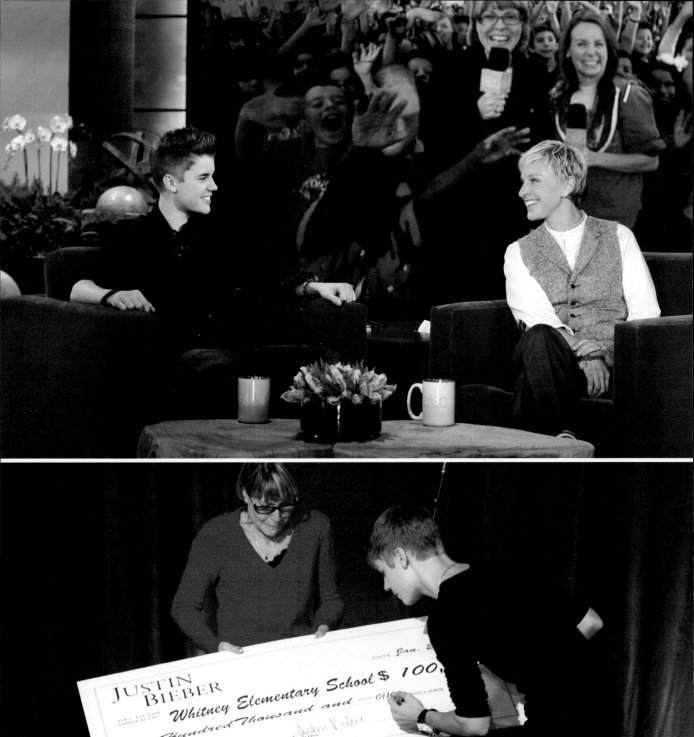

I kept my promise and made it to Whitney Elementary on December 16, 2011. I was pretty excited to tour the school and meet everyone. I popped in and out of the classrooms to say hello, talking to as many of the students as I could along the way. I answered their questions and shared my personal childhood struggles of being raised by a single mother in low-income housing and having to rely on food banks and charity donations for clothes. I told them all about how when I was young my grandparents helped out my mom, but I didn't have a lot as a kid either. Just seeing how happy they were made that day really special. I was so happy to meet everyone—it was an experience I don't think any of us will ever forget.

When my tour of the school was complete, everyone gathered in the multipurpose room of their school where I put on a private concert just for them. I was only supposed to sing a couple of songs from *Under the Mistletoe* for 650 students and faculty that day, but I ended up doing about five songs. For me, that was one of the most memorable shows I have ever done. To top off the already amazing day we all shared, *The Ellen DeGeneres Show* and Hasbro also donated an additional $100,000 in toys—one for every child—for the holidays.

I've heard that Whitney has received well over 1 million dollars in donations since Ellen first adopted their school. I know many of the children think my coming to their school was an early Christmas gift to them, but the truth is, spending time with the students that day was the best gift I could ever have received. I enjoy doing that kind of stuff more than any other type of appearance because it's just between me and the kids. I usually don't like it if the press is there, and most of the time I restrict their access so nothing can interrupt our valuable time together. I love talking to kids and hearing how they have become best friends around the world because of my music. For me, that is one of the coolest things about my job, because I am from a small town and I never thought I would leave. When we talk, I hope they see me as someone to aspire to—that if I can break out of my circumstances, they can too.

I like the idea that through my music I am helping people all around the world. I want to be known as an ambassador of people. Since music is the universal language, I can influence people's lives in a positive way—something we can all aspire to.

"My goal is to make people happy, to inspire them."

"On March 11, 2011, the world was watching as Japan suffered from a catastrophic 8.9 magnitude earthquake, the worst quake in the country's history. A devastating tsunami was triggered, causing a 23-foot wave which wiped out cities, towns, and villages along the coastline and resulted in the loss of countless lives. In the aftermath, the Japanese government ordered thousands of residents near a nuclear power plant in Onahama City to evacuate because the plant's system was unable to cool the reactor. The reactor was not leaking any radiation but its core remained hot even after shutdown. The plant is 170 miles northeast of Tokyo."

# PLAYING JAPAN

## Osaka and Tokyo
## May 17–19, 2011

I was in Liverpool, England, for a show when I first heard about the crisis in Japan. My heart went out to all of the families who lost loved ones and who would eventually be displaced by the utter devastation that took place afterward. We were scheduled to do two shows in Japan in May, one in Tokyo (which is 170 miles from where the nuclear reactor was located), and the other in Osaka, which is a little further away.

At the time, there was a lot of concern about traveling to Japan. I'd heard that many other performers were cancelling their appearances there because of the potential exposure to radiation. We were equally concerned at first, but after Scooter and I talked it through and looked at every possible side of the argument, we both wanted to keep our commitment and go. I mean, this is what you do it for. You do it not only for entertainment, but to support your fans the way they support you. If I abandoned my fans now, I'd be abandoning everything I stand for. One of the oldest sayings in show biz is, "The Show Must Go On." And so for us, it would.

Fear affects a lot of people and holds them back from doing things in life that ultimately matter. I look at these as opportunities and as the moments in life that separate the good from the great. These are the situations that come up where I can prove that I live for my fans. Then more than ever, they needed something to help them start to heal, and music, whether it's mine or anyone else's, is always a good start.

Once Scooter and I were firm on our decision, we had a meeting with the crew to get them on board too. I was pretty shocked when a bunch of our musicians and crew refused to go.

They started talking behind the scenes, saying it was wrong to make the trip and that we didn't care about them. We are like a tight-knit family so it kind of freaked me out to hear some of my team talk that way about us. With all of the smack talk, we immediately called a team meeting so I could tell everyone how I felt. I said that I was going to Japan whether they did or not. I tried to explain that my fans expected me to be there and under the circumstances, I wasn't willing to let them down ... especially in a time of need. I was hoping everyone would band together, but I wasn't totally convinced they would after I left the room.

Once I was gone, I heard later, Scooter looked at everyone and said, "Listen up, he is 17 and he has more courage and heart than you guys. Whether you say you want to go there or not, we all have responsibility in our life to other human beings. All of you need to make a decision. If you don't want to go to Japan, then you don't need to be a part of this team at all and you can go home and I will hire someone else. So, either man the *&%$ up or get off my tour."

It took a while to win them over, but eventually only three people left the crew and the rest said that if me and Scooter were in—and they meant both of us—then they would go. Everyone knew that Scooter wasn't originally scheduled to be in Japan, so in a way they made us both prove our loyalty to them and the Japanese fans by being there. Scooter flew 16 hours from Australia to LA for a meeting he couldn't change and then hopped on a flight to Osaka so he could be there before we arrived from Taipei, Taiwan. By the time we landed, he was already at the airport in a show of solidarity and to make sure they understood that if he could make it happen, no one had an excuse not to be there. #Beast

When we got to Tokyo, I wanted to do something special for some of the victims of the earthquake and tsunami, so we had several kids from the areas that were affected come to Tokyo to spend the day together. We met at the American Embassy, where the Canadian and Japanese Ambassadors joined us for an unforgettable day for all of us. We all hung out, played some songs, took lots of pictures and, most important of all, listened to their stories. For most of them, this was their first trip to Tokyo, and for some, their first time away from their homes. I will never forget the kids I met, especially a girl named Ayaka, who lost her sister, parents, and grandparents in the quake.

We surprised everyone by arranging for them to stay in Tokyo so they could come to my show the next night. We gave them all front-row tickets so it would be extra special. I even brought one of the girls on stage to be my "Lonely Girl" and sang to her during the show.

The Japanese audience was very grateful we came to entertain them—as so many other stars had cancelled their tours. After we left, we arranged for Apple to donate computers to each of the kids we met that day as our way of helping them move on toward their future. I heard that Ayaka is set to start college in the United States this year. It makes me feel really good to know she is doing so well.

I left Japan proud of the time we spent there, especially the time I got to spend with the kids whose lives had been so drastically changed by one single event. I was reminded of the importance of living a life to help, support, and care for others. Whether you think so or not, one person can make a difference in someone else's life.

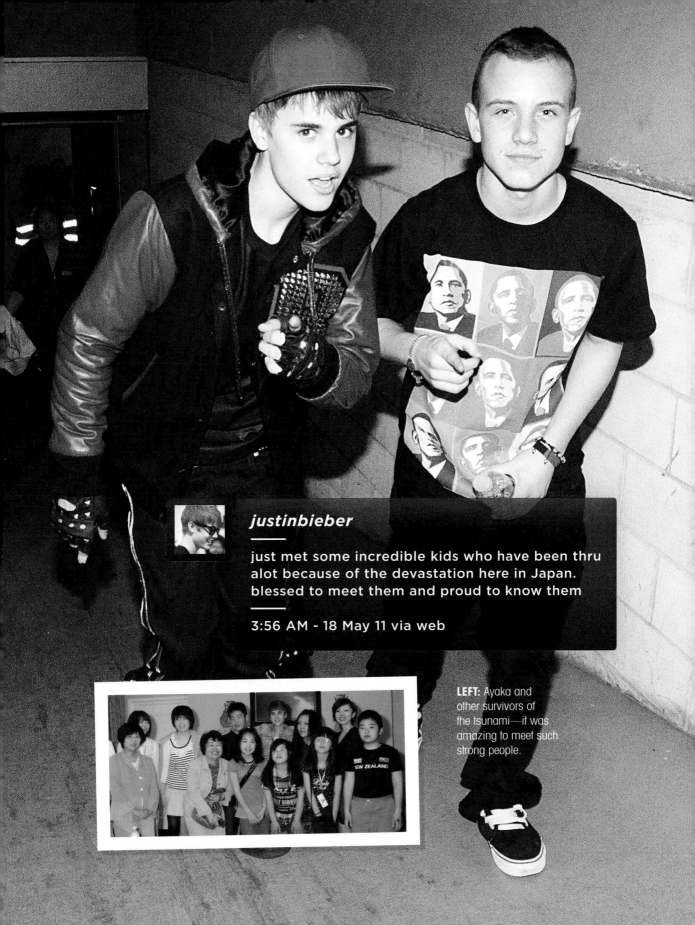

### justinbieber

just met some incredible kids who have been thru alot because of the devastation here in Japan. blessed to meet them and proud to know them

3:56 AM - 18 May 11 via web

**LEFT:** Ayaka and other survivors of the tsunami—it was amazing to meet such strong people.

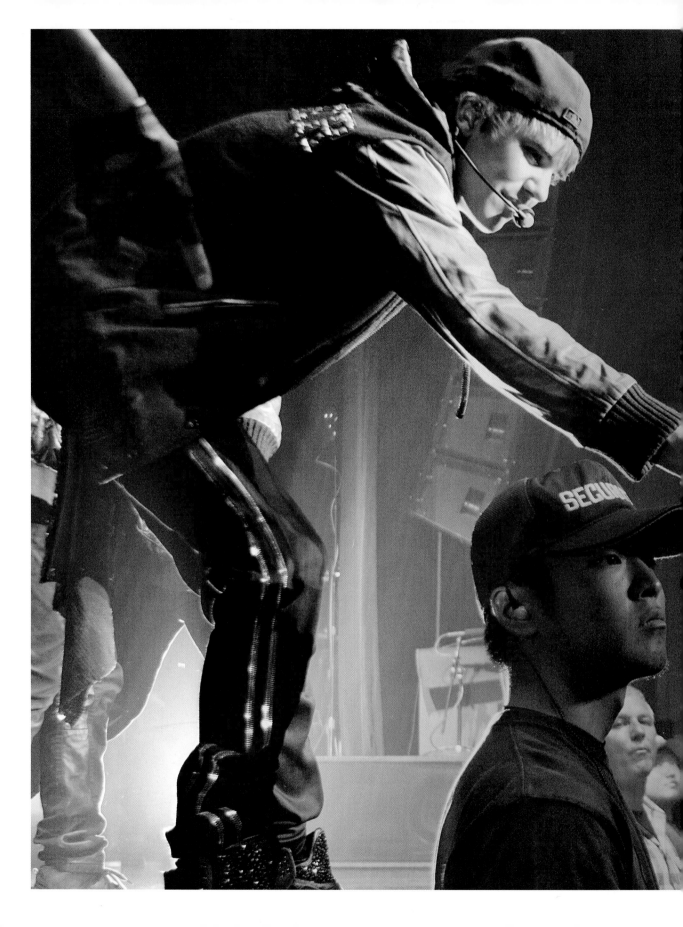

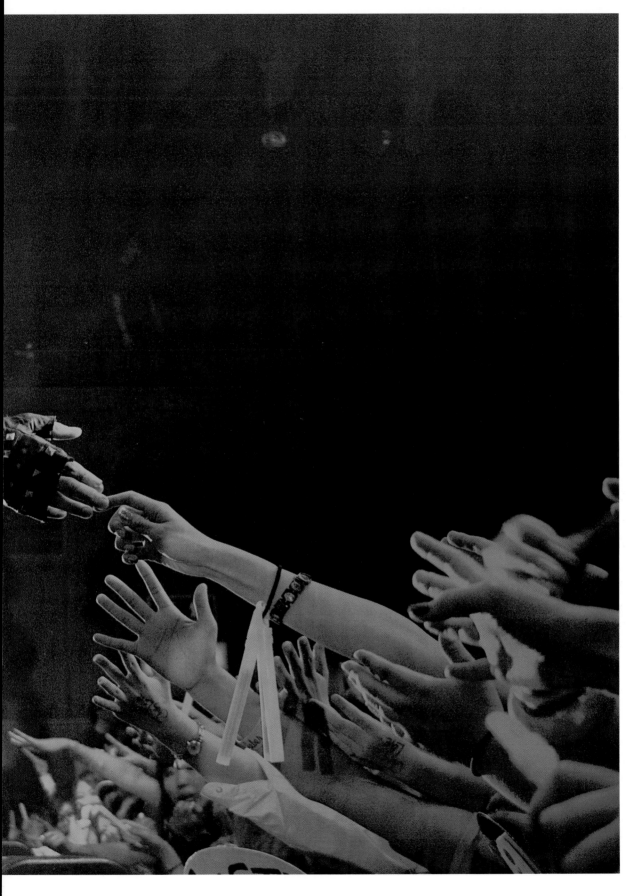

Reaching out in Osaka. I love connecting with you guys!

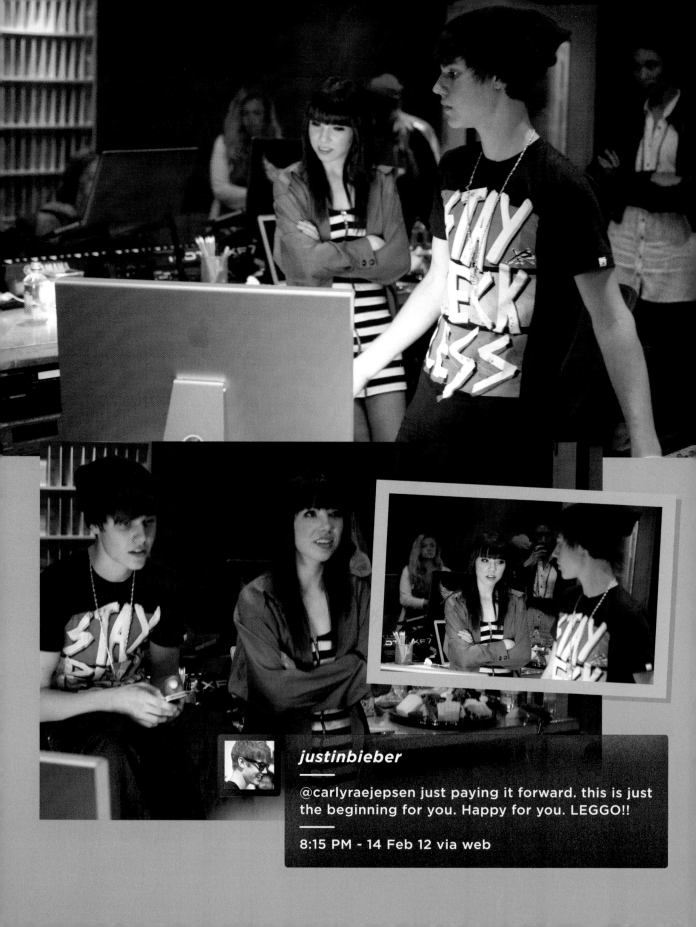

**justinbieber**

@carlyraejepsen just paying it forward. this is just the beginning for you. Happy for you. LEGGO!!

8:15 PM - 14 Feb 12 via web

# CARLY RAE JEPSEN

Stratford, Ontario, Canada
December 2011

I was home in Stratford to celebrate Christmas with my family and kept hearing this song, "Call Me Maybe," on the radio. It's a really catchy tune—you know, the kind where you remember all of the words after hearing it a couple of times. Anyway, whenever I was driving around with my friends and we'd hear the song, one of us would have to turn it up so we could sing along. Even though it was doing well on the Canadian charts, I thought it was an amazing song that should be doing better outside of Canada so I tweeted, "Call Me Maybe is the catchiest song ever."

I kept asking my friends about the singer—who is she?

They told me her name is Carly Rae Jepsen— a singer who had been on *Canadian Idol* in 2007 and had a few hits since then.

OK, got it. But was she signed to a label?

No one knew.

It didn't take Scooter long to call me after reading my tweet, and when he did, I asked him to find out if she was signed to anyone. As soon as we found out that she wasn't signed outside of Canada, we had an opportunity to sign Carly. I liked what I heard, and I thought, what better way to use my name than to help another artist, who I think is great, get out there for everyone else to hear? #payitforward

Since then, she has had tremendous exposure and success all around the world. I am really proud of her. I am happy that I was able to do for another artist what Usher once did for me. At the end of the day, it's just my own way of paying it forward. When I first started, after Scooter found me, we went to Usher to help me get signed and get my name out there. He's been my mentor ever since. I feel like I have a duty to do the same for other up-and-coming artists who I believe in. There's no greater feeling in the world than knowing you've given someone something they needed, then sitting back and watching them take off and fly.

# GROWING UP

At the end of the day, I'm not completely grown up. I'm still learning. I'm going to grow up how I grow up. I'm not going to try to conform to what people want me to be.

Talking to my fans in the pit in Lima. It's so important to me to meet as many of you as possible.

# FAMILY

Even though I didn't have a so-called "normal" family growing up, I have made it a priority in my life to put them first. I love my family and I'm very protective over everyone—especially my little brother and sister. I'm the kind of guy who never wants to let anyone down, whether it's a friend, family, or even my fans. I have always been like that. I know what it is like to feel let down and I never want anyone else to feel that way.

Growing up, my grandparents were ever-present in my life. They have been a steadying force throughout the years, making it possible for me to pursue my dreams, even as a little boy. They recently retired and since they had given so much to me growing up, I really wanted to do something extra special for them. I decided to buy them a new house they could settle in and enjoy this phase in their lives. I wanted my grandmother to have a bigger kitchen to cook in—especially when we all come back to see them during Christmas. And, when I came home for Christmas, I had one more surprise for them—a brand new car, that I parked in their driveway and gave to them as a small token of how much they mean to me. I also left a little gas money in the glove box so they didn't have to worry about filling up the tank. I can honestly tell you that nothing in this world feels better than helping the people who have loved you their entire life. In their eyes, I will always be their little grandson Justin, and I am just fine with that.

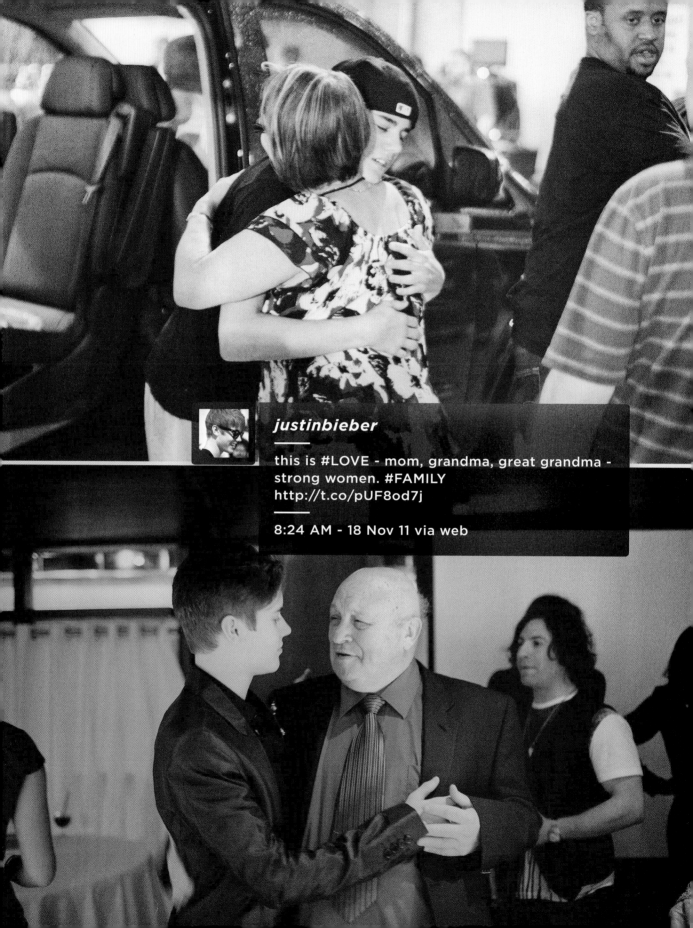

**justinbieber**

this is #LOVE - mom, grandma, great grandma - strong women. #FAMILY
http://t.co/pUF8od7j

8:24 AM - 18 Nov 11 via web

I couldn't have made it anywhere in this world without such an amazing family. I'm so lucky and so blessed to have them behind me.

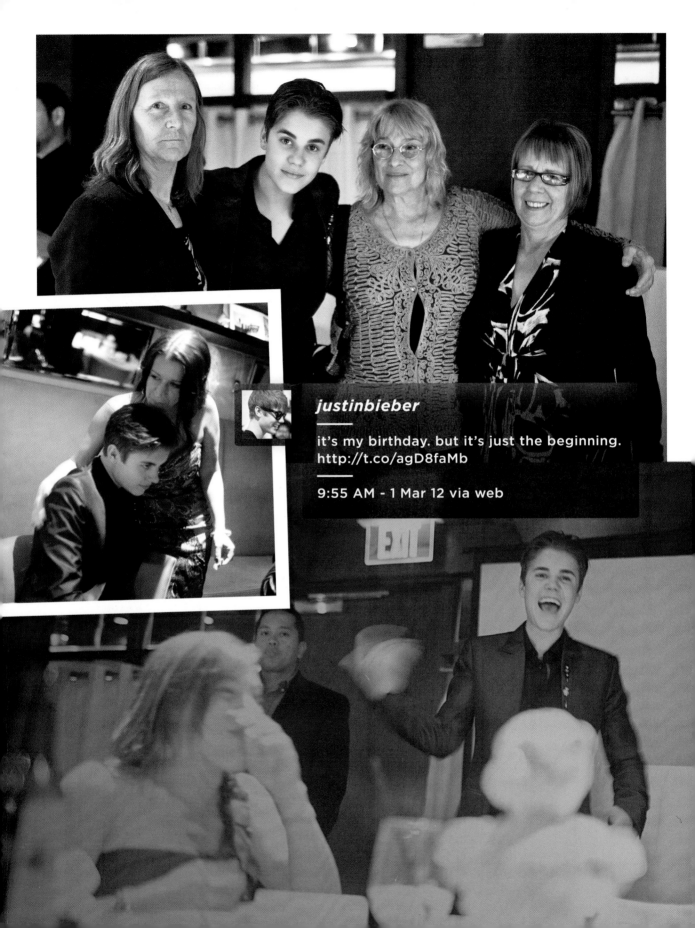

**justinbieber**

it's my birthday. but it's just the beginning.
http://t.co/agD8faMb

9:55 AM - 1 Mar 12 via web

# CAUSE FOR CELEBRATION

**Los Angeles, California**
**March 1, 2012**

For most teenagers, turning 18 is a pretty big deal. I was no exception. I knew that my 18th birthday would be a milestone celebration, but I hadn't anticipated how emotional it would be for everyone around me. To me, it was a big birthday for sure, but to those who have watched me grow up and mature over the years, it was so much more!

I wanted to share the big day with my closest friends and family, who all came to California from Canada, New York, Atlanta, and other places around the country for a weekend celebration. We planned a small dinner the night before my actual birthday at the SLS Hotel in Los Angeles. Since it was also my cousin's birthday that same week, I had a cake made and sang "Happy Birthday" to her that night too so she didn't feel left out or think we forgot it was a big day for her too.

My mom put together a slide show of pictures from my first 18 years of life. Uh, yeah, it was a little embarrassing, but also super touching. My mom is a pretty typical parent who has taken a bazillion pictures of me throughout the years, so I know it took her a long time to sort through all of those old family photos and pick out the ones she wanted to include. There were a few

pictures of me and my dad wearing fake moustaches that were pretty funny. In addition to our family, she also included pictures of Kenny, Scooter, Fredo, Dan, Carin, Allison, Ryan, Chaz and everyone else who has been a part of my life too. It was kind of funny to see some of the old pictures and how much everyone has changed over the years. She even set the slide show to the Tragically Hip's song "Wheat Kings," Boyz II Men's "On Bended Knee" and Michael Jackson's "Man in the Mirror"—three of my all-time favorite songs. It was really touching to see all of the work she put into that very special present, although I will say that there were a few pictures in there I'd rather forget! Even so, it was really fun to see all of those shots, reminiscing and remembering with everyone who was there that night, especially my mom and my dad, who flew to LA with my little sister and brother, Jazmyn and Jackson.

Even though Jazmyn and Jackson didn't come to the parties, I got to spend some quality time with them throughout the week they were in LA, taking them to Chuck E. Cheese and hanging out doing fun things together as a family. I wish I had more time to spend with them, but at least we have a blast whenever we do get together.

"The next night we had a blowout bash at the Beverly Wilshire Hotel in Beverly Hills. Scooter surprised me by bringing Mike Tyson and other friends including will.i.am, Cody Simpson, Carly Rae Jepsen, Kim Kardashian, Jaden Smith, and many others were all there too. Yeah, the party was swaggy. Jaden surprised me with a performance by Lil B who sang his 'Justin Bieber' song for everyone. I don't know if you've ever heard it, but if you haven't—check it out. I thought it was an awesome gift! It was a really fun night, one I won't soon forget!"

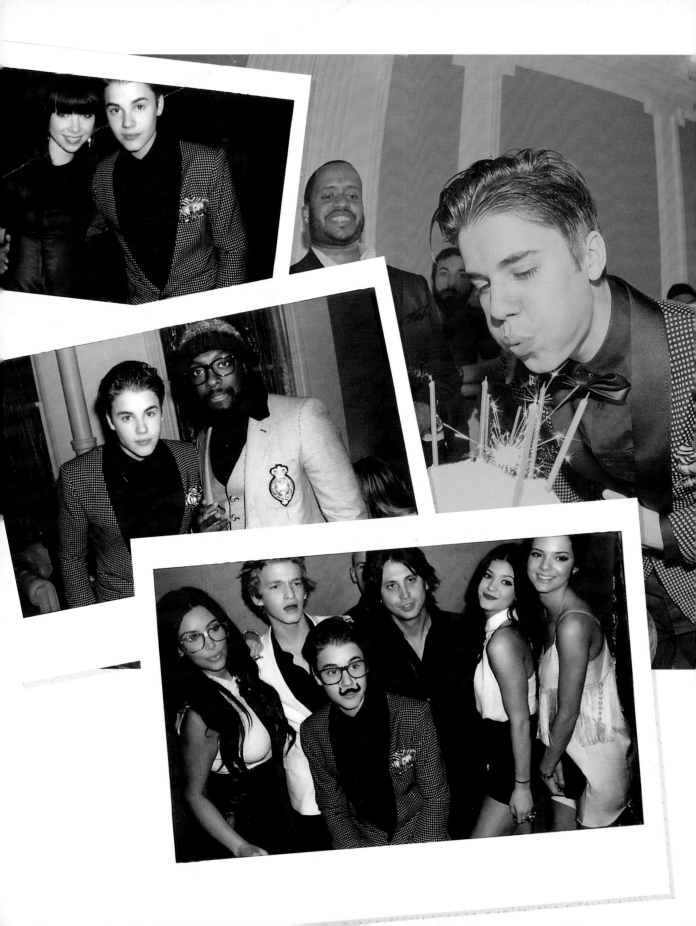

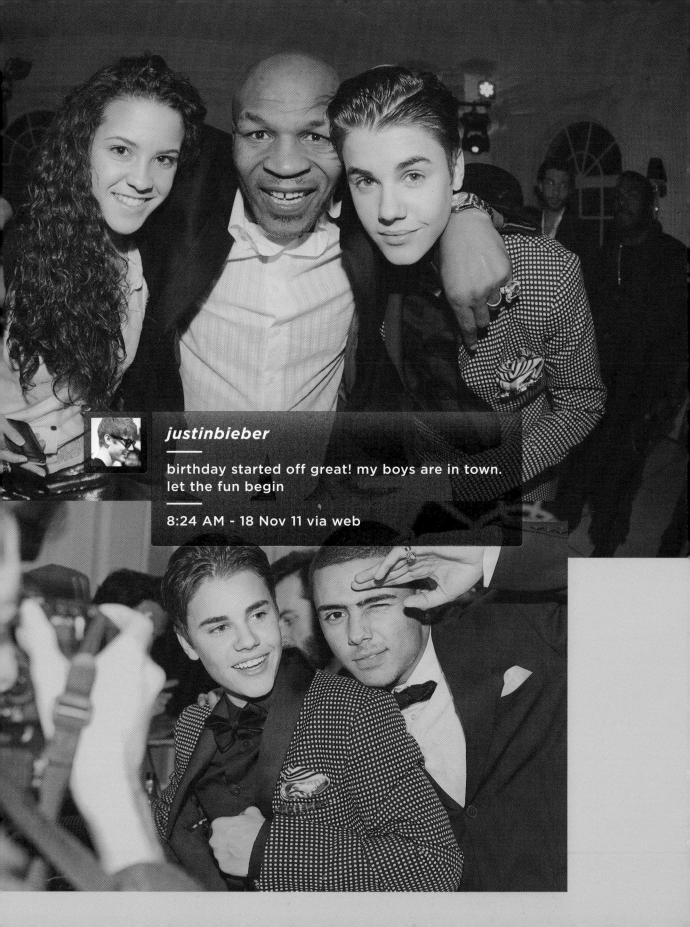

**justinbieber**

birthday started off great! my boys are in town. let the fun begin

8:24 AM - 18 Nov 11 via web

Before I turned 18 I think it was a little easier for me to play the "kid" card, you know, get away with things you can't really do when you're an adult. Don't get me wrong, I still love a good joke or pulling pranks on everyone, but I also felt a new level of responsibility and the need to take charge of my life in ways I didn't really think about all that much before. There are people who try to grow up too fast, especially kids who grow up in show business. They turn 18, and they're like, "I'm not a kid anymore." Yeah, that wasn't really how I saw it. While I definitely want people to know I'm not a kid anymore, at the end of the day, I'm not completely grown up either. I want to do things at my own pace—whatever that may be—and have the freedom to make mistakes so I can learn from them. And you know what? I'm still learning, and I hope I keep on learning every day. I hope my fans will grow and learn with me.

Look, I'm young and I still love to have fun. I'm not perfect, I think everyone makes mistakes, and that's what life is about. I've got such a great family and mentors surrounding me that I know the people around me will do everything in their power to help stop me from making a life-changing bad decision. To be honest, I'm very careful about that too, especially because I've seen it happen too many times in other people's lives. I've got a once-in-a-lifetime opportunity, and even though I am having a blast, I am not going to deliberately trash it so some people might see me as cool. I could be my own worst enemy, but I don't want to mess this up. I've got a pretty good thing going that's worth choosing the right path for.

Now that I'm older, I'm not going to conform to what people want me to be or suddenly go out and start partying—having people see me with alcohol. My goal is never to do anything that causes kids and parents to not respect me. There are some artists that parents won't even let their kids go see because they think they're a bad influence—I'm proud to not be one of those guys. I just want to be a good influence on people, and the best way I know to do that is to live exactly the way I do—in a way that if someone says something crazy about me, no one would believe them!

When I think about my role in this world, I want to be able to do what Michael Jackson did by choosing songs with clean lyrics, generously giving back to others and being someone who little kids love every bit as much as their grandparents. In a perfect world, I want my fans to grow up with me and to be someone who is respected by everybody. I want to be someone that people can look up to and I want to live and be out there as a good role model.

Scooter is always reminding me to stay humble and warning me not to buy anything too flashy. He taught me not to love money because once you do, all you've got is a big house, fancy cars, and an empty heart. That is so true, which is why we aren't about that type of showiness. We always try to keep things real and down to earth. It can get kind of annoying, but I get it, so I was completely blown away when Scooter presented me with a brand new, 2012 Fisker Karma on *The Ellen DeGeneres Show* as a birthday present from him and Usher.

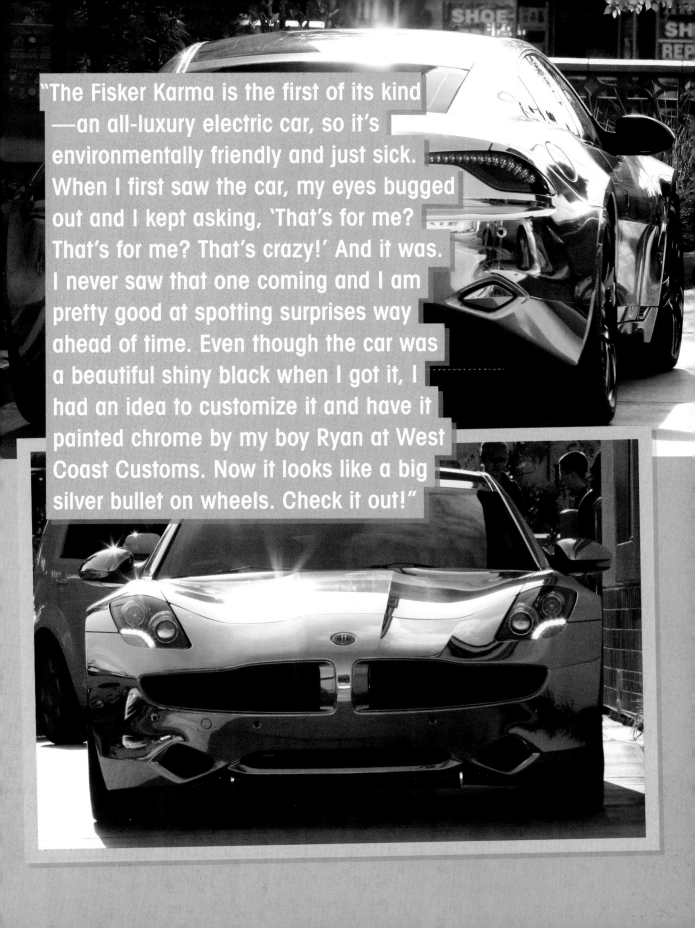

"The Fisker Karma is the first of its kind —an all-luxury electric car, so it's environmentally friendly and just sick. When I first saw the car, my eyes bugged out and I kept asking, 'That's for me? That's for me? That's crazy!' And it was. I never saw that one coming and I am pretty good at spotting surprises way ahead of time. Even though the car was a beautiful shiny black when I got it, I had an idea to customize it and have it painted chrome by my boy Ryan at West Coast Customs. Now it looks like a big silver bullet on wheels. Check it out!"

# A HIGH SCHOOL GRADUATE

May 2012

2012 has been a year of many big events. Not only did I turn 18, I graduated high school too. Throughout my time touring over the years, I quietly and diligently continued my studies through the high school I would have attended back in Stratford. My team made sure I kept my education a priority, so I wouldn't fall behind or, worse, not graduate. And everyone else around me made sure I didn't slip up or blow it off. Whenever I'd question why I was studying something I never thought I'd use in real life, like geometry, Kenny set me straight. He'd say, "Boy, it is like my daddy always told me—you take these classes because it helps your brain think analytically. Math is like exercise for the brain. You may never use an algorithm or an equation, but it helps you with critical thinking."

I didn't know it at the time, but Kenny was right. No matter what your goals are in life, there is nothing more important than your education. So even though I was busy touring all over the world and have the craziest schedule for a kid my age, I still earned my degree.

I would have attended the commencement ceremony with the rest of my classmates and friends, but I'm pretty sure that would have taken away from the moment for everyone else—something I'd never want to do. I did score a graduation cap and gown from Ellen while I was on her show, so at least I could look the part.

"No matter what your goals are in life, there is nothing more important than your education."

**If someone is stalking you without a camera, it is illegal, but if they are doing it with a camera, it is somehow perfectly fine. I don't get that difference and I suppose I never will.**

**--**

I love taking photos, to be on the other side of the lens for a change.

CHAPTER 7

# TAKING A STAND

# TAKING A STAND

When it comes to dating, I am a regular teenager. There are just some things I am trying to keep private because I am young and figuring it out. I am learning about trust and the joys and struggles of it. I like being with someone who is smart and who I can have an actual conversation with. It doesn't make you weak or any less of a man if you treat a woman with respect and spoil her a little bit. Remember guys, if your friends give you a hard time about being romantic it's just because they don't know how to treat their lady right.

So let's just get to it … in 2011 a woman came out of nowhere and filed a paternity suit claiming she was pregnant with my child. I was a minor at the time and she was not, and she had absolutely no evidence to verify her claim. In fact, we had never even met. The media (including legitimate news outlets) picked up on the story and ran with it as if it were all true. Whatever happened to responsible journalism? Aren't reporters supposed to check their facts before writing their stories? Maybe it's just me, but I could never get away with making up some story for a school project and passing it off as real! My teachers would have flunked me for even trying something like that!

Another thing I don't really understand is that when someone is stalking you without a camera it is illegal, but if they are doing it with a camera it is somehow perfectly fine. I don't get that difference and I suppose I never will.

One of the worst downsides of fame is the freedom and liberties the media take when it comes to reporting on a celebrity's personal life. At the same time, without the media, you can't do your job so I guess it's a give and take. It's hard enough to be a teenager going through regular teenage stuff, but doing it under the microscope of the press just amplifies what's already awkward to begin with. That would be tough for any kid. But when it comes to reporting things about my life that aren't true, well, that crosses a line that I believe is unfair.

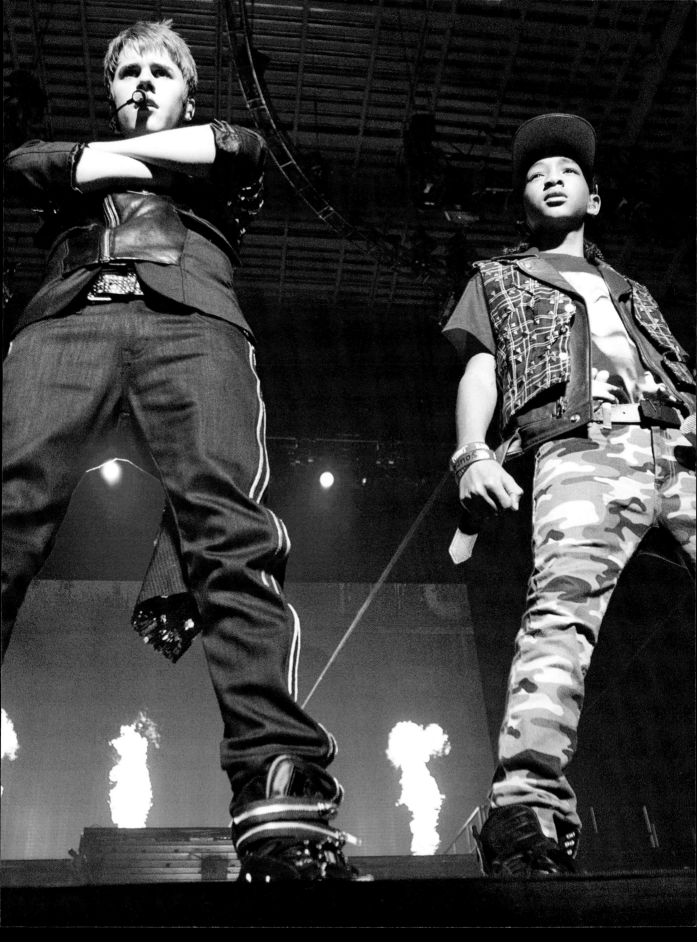

Me playing a game of "Paparazzi" with Kenny—he loves it really!

Why has it become more necessary to sensationalize the news for people to get them to read a newspaper or buy a magazine at the cost of the truth?

When did gossip websites become viable sources for legitimate news?

Hey, I've always had a good relationship with the media, and for the most part, the media and paparazzi have been pretty good to me. If it wasn't for them, I wouldn't have nearly as close a relationship with you, my fans, but at the same time I just wish that they didn't have to go about getting the stories in the way some of them do. When the paparazzi are nice to me and respectful, I am never afraid to have a conversation with them. I'll chat to them, pose for a few shots, thank them and be on my way. But it's not OK when they come at me aggressively and don't respect my space because they are looking at me as a product and not a person.

There's a misconception that I hate the paparazzi—I don't, I simply don't like the aggressive paparazzi. Whenever you see me laughing and having a good time with the paparazzi, it's because we've had a pleasant exchange. They are grateful that I'm willing to work with them, while I appreciate their respectful approach. However, there have been times where the interaction has been combative from the start. Like, whenever you see me getting angry or upset in the media what you don't get to see on camera is how those people came up to me and said things like, "Hey Justin, why are you such a punk lately?," "Your mom is ugly," and "Your little brother and sister are ugly babies." They literally yell stuff like that to try and get a rise out of me. Famous or not, saying terrible things about my family is completely unacceptable. And if they aren't going after my family, they're coming after me, swearing, saying the most horrible things ever, even calling me white trash—which is kind compared to the other things they've thrown at me.

Nice—*Not.*

Although most of the press isn't like this there is a certain type of paparazzi who do stuff like that, saying the rudest things ever because they just want a picture that makes me look angry or upset. It's just not right.

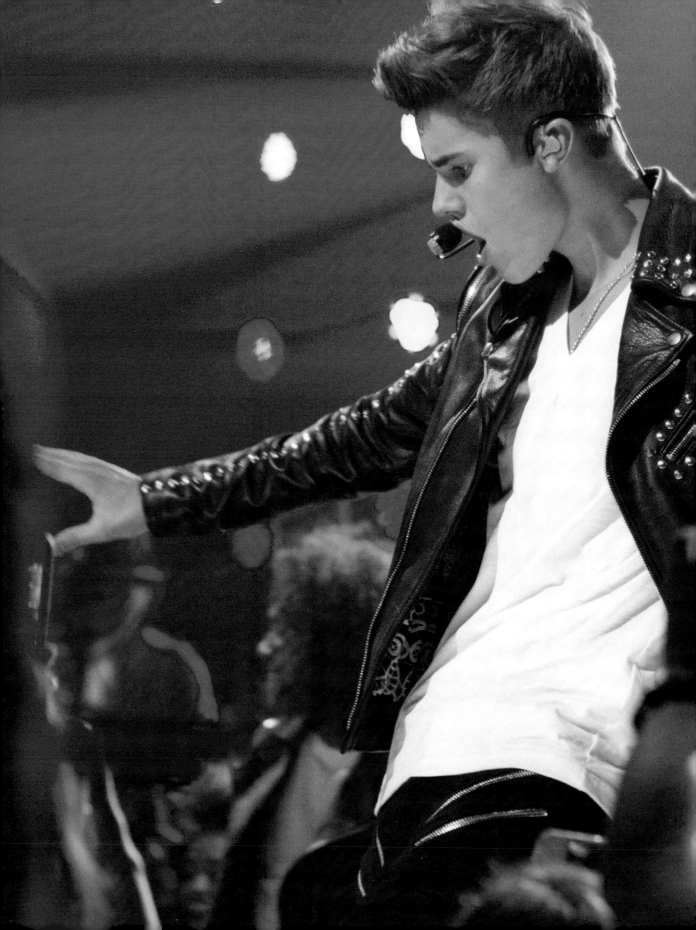

I don't want to ever get to a place in my life where accepting this type of harassment and name calling is OK, because it's not. It's a form of bullying, and under any circumstance it's totally inexcusable.

At some point when growing up almost every kid is bullied—even me. Believe me, nobody likes it. What I have learned is it's the job of the bystander to stand up and do something about it. When you are being bullied it is hard to react and you have to stand up for yourself. I'm not saying you have to get into a fight, but be willing to defend yourself if you have to. No one has a right to make you feel small, worthless, or less than them—don't give anyone that much power over who you are or how you feel about yourself.

Michael Jackson was someone who always talked about making a change, and his message and legacy is something I want to keep going. So, if you see someone bullying it is really important that you step up and say something and help put an end to it. That is why I got involved in the fight to help bring the movie *Bully* into the mainstream, to help it get a PG-13 rating. I wanted to start a conversation amongst my peers because I know that if we can get people talking about the important issues, you and I and the rest of my fans all around the world can make a difference together for the next generation.

**justinbieber**

im smiling all day. u cant phase me. rumors are rumors. lies are lies. we know the real and we #BELIEVE. Hi Haterz. WE R COMING! U cant HIDE

3:45 PM – 10 Mar 12 via web

**justinbieber**

stay true to yourself. they can never break us. we are a family. #TEAMBIEBER goes HARD!

8:20 AM – 8 Nov 11 via web

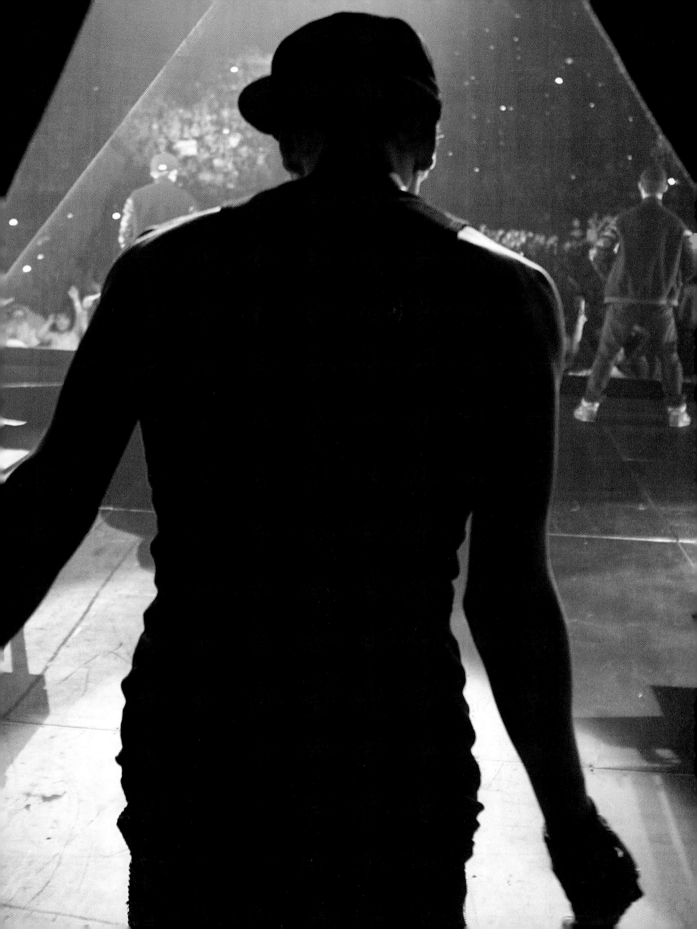

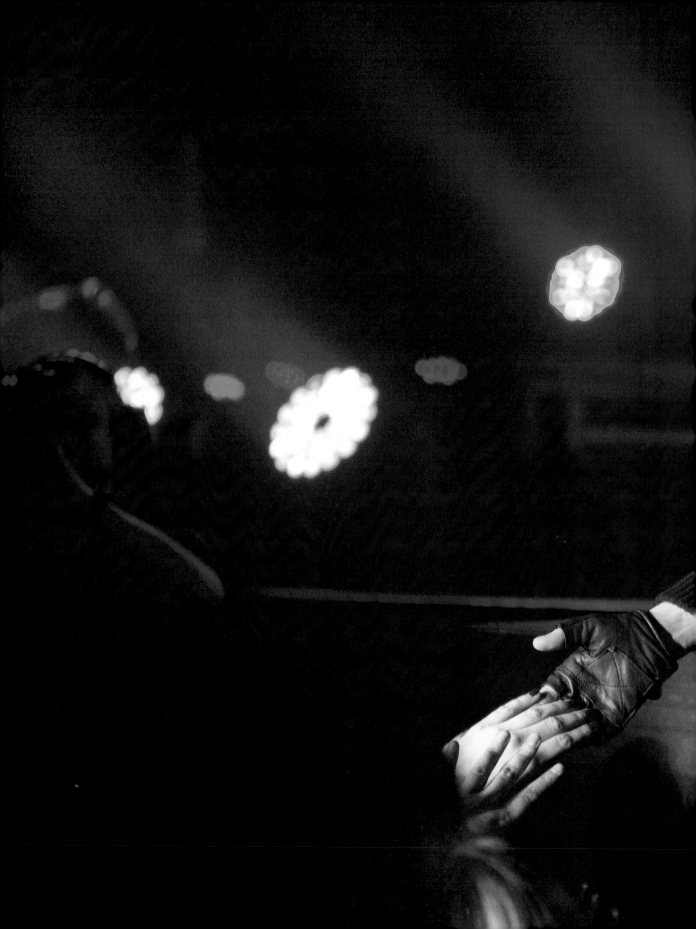

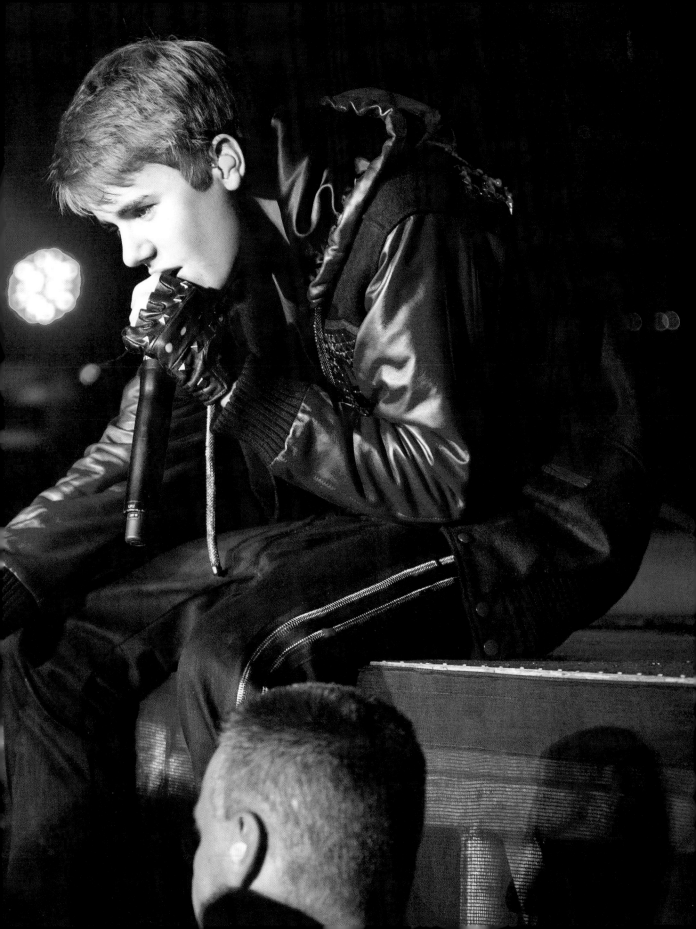

# My fans have believed in me from the start and I have always believed in them—and look where we are today. Where can we go when we believe in each other? Together, anything is possible!

**--**

In the recording booth working on *Believe*.
It's OUR album. OUR Moment. #Believe

# CHAPTER 8

# BELIEVE

# BACK IN THE STUDIO

I've got a lot of musical influences in my life, ranging from my mom, who laid my musical foundation with '90s R&B, to my dad's mom who taught me how to play the piano; Usher, who teaches me about smooth soulful sounds; Dan and my dad, who introduced me to classic rock; Kenny, who listens to old-school R&B, rap and soul; and even Kobe Bryant, who reminded me how Michael Jackson studied other artists throughout his career. Before going into the studio to record *Believe*, I started listening to old records and studying the runs, paying attention to the arrangements and such. I think that research had a positive effect on the creative process in making the album. At the time, the rest of the world was very focused on electronic and dance music, while I had been familiarizing myself with and becoming more aware of different types of music that blend soul stuff with old-school Motown and a modern beat.

When I went into the studio to record *Believe*, like everything I do, I had a very specific goal in mind. To me, this new album had to be the best one yet, to prove to those who doubt me that I am not some pop-star flash in the pan. I made this album with a "make it or break it" attitude. Now that I am 18 years old, I think there are a lot of critics out there who think I am going to just disappear like other young stars have. But you know me. I'm competitive. I want to do the unexpected. And like Justin Timberlake, Usher, and Michael Jackson, who made that transition from child to adult star before me, I'm not going anywhere. Period.

I'm aware there are people out there who hate my music who haven't even listened to it. They just hate the idea of someone who is young making it big. They think I am some manufactured singing robot instead of a guy with real talent. Every moment of every day I am ready and willing to prove those who doubt me wrong. I love being the underdog. It gives me and my fans something to do and strive for next.

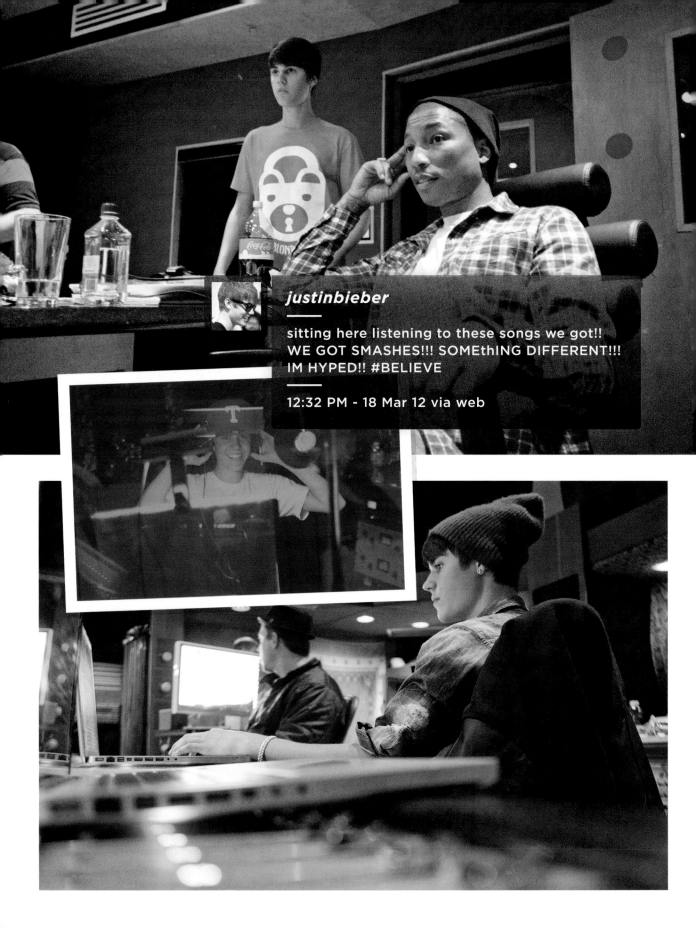

**justinbieber**

sitting here listening to these songs we got!!
WE GOT SMASHES!!! SOMEthING DIFFERENT!!!
IM HYPED!! #BELIEVE

12:32 PM - 18 Mar 12 via web

While charting my own course, I have often thought about Michael Jackson and his career, and for me, making *Believe* is like Michael making *Thriller* after his insane worldwide success with *Off the Wall*. In making this album, I knew my biggest challenge was making people feel like it's cool for them to like my music. So when I went into the studio, it was clear to everyone I work with that I wanted to take more risks, try some new approaches to my music and creatively challenge myself to bring my art to a new level. In order to do this, I was a lot more hands-on in every aspect of recording the album. I had no choice because I wanted it to be perfect. Every detail mattered.

While I recorded *My World* in a couple of weeks and pretty much allowed other people to creatively take the reins, it took several months of studio time to get *Believe* to the place I thought it needed to go. I've learned a lot since *My World*, and I was willing to take my experience and skills and put them to work. And I had a great team around me, including my vocal producer, Kuk Harrell, who has been with me from the start. Kuk has worked with some of the biggest names in the business, including Beyoncé, Rihanna, Mariah Carey, Chris Brown, and Usher, just to name a few. Throughout the years, he has taught me to become more aware and precise in the studio—and has helped give me the confidence to be the final word on my sound.

I feel like it's my responsibility to be the greatest I can be. If I start making terrible music, I don't expect people to like me. But as long as I'm making great music, then there's no reason for people to dislike me. People just need to take a chance and listen. I'm here for a reason, and I'm here for a lifetime.

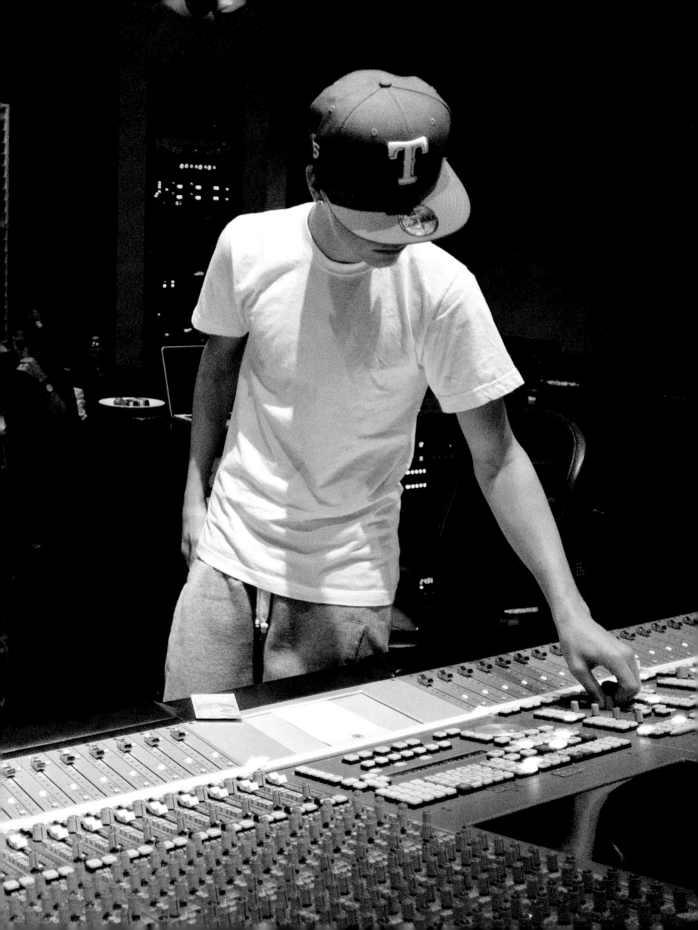

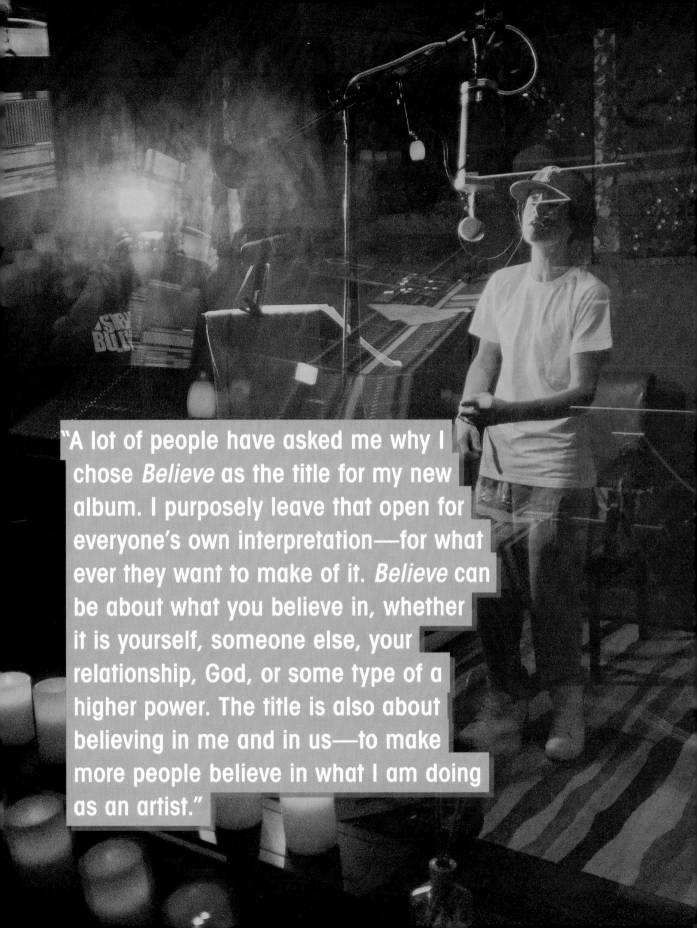

"A lot of people have asked me why I chose *Believe* as the title for my new album. I purposely leave that open for everyone's own interpretation—for what ever they want to make of it. *Believe* can be about what you believe in, whether it is yourself, someone else, your relationship, God, or some type of a higher power. The title is also about believing in me and in us—to make more people believe in what I am doing as an artist."

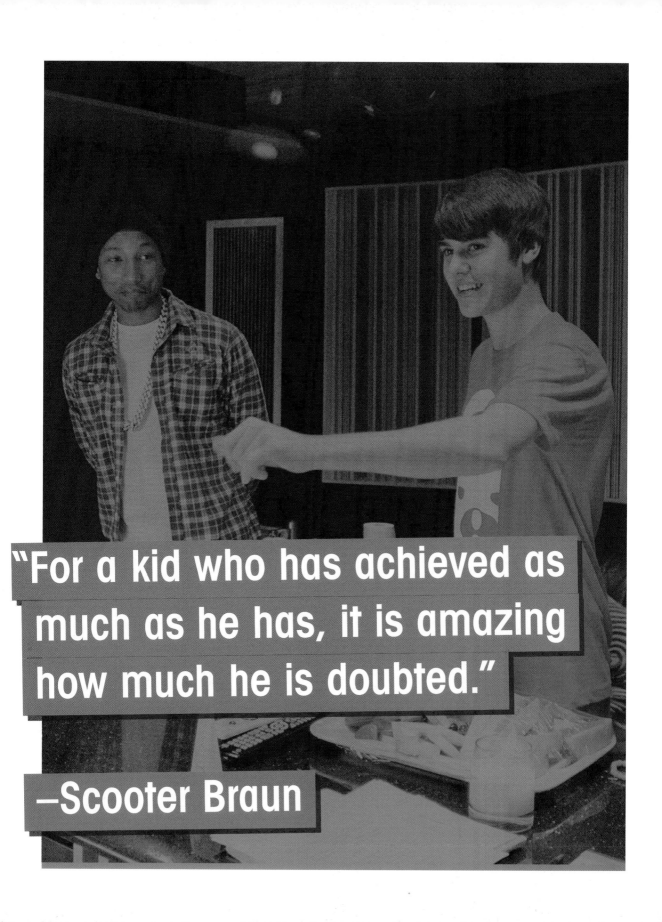

"For a kid who has achieved as much as he has, it is amazing how much he is doubted."

—Scooter Braun

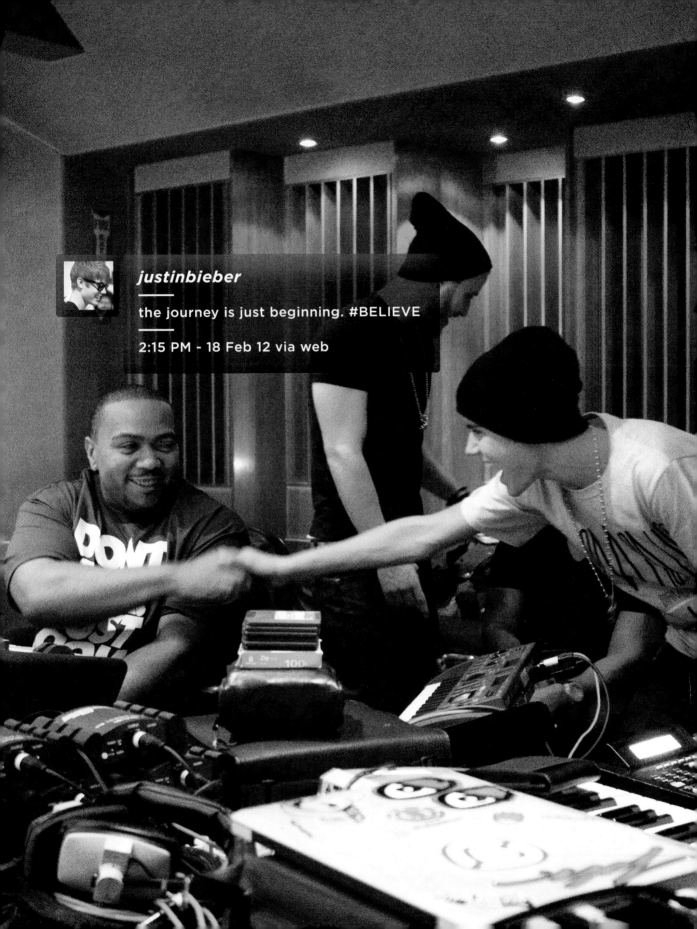

**justinbieber**

the journey is just beginning. #BELIEVE

2:15 PM - 18 Feb 12 via web

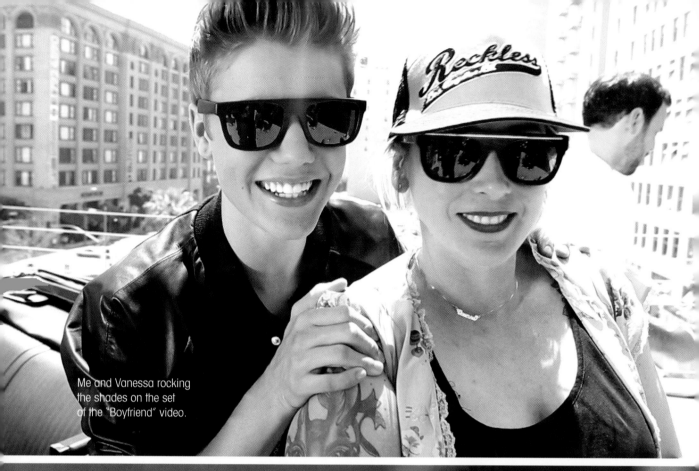

Me and Vanessa rocking
the shades on the set
of the "Boyfriend" video.

# BOYFRIEND

I was very excited to release "Boyfriend," the first single from *Believe*, because it was definitely a different sound than my fans were used to hearing. It was also a long time coming, so I knew it had to be killer. The song was co-written and produced by Mike Posner and Mason Levy. Our goal was to make something that all of our friends would want to listen to over and over again in the car. I really love the process of collaborating, especially when it comes to creating great music. As an artist, I can't possibly think of everything myself, so I really appreciate it when people I work with are open to working on ideas with me so we can make the best music for my fans.

So, I guess we scored on that goal because "Boyfriend" sold well over 521,000 units in its first week on the charts in the United States alone! The opening digital sales total for "Boyfriend" made it the number one digital single first week in worldwide history and is the number-one-selling music single in my record label Universal Music Group's history. Man, I was blown away.

A lot of people have said they didn't like my music, but once they heard "Boyfriend" I think they had a change of heart—and that was my goal, to make more believers. I think they had the chance to hear a different side to my music—a more soulful and mature sound with a flavor of rhythm and blues mixed with hip hop—all different styles than people are used to hearing from me. I even threw in a reference to one of my favorite characters from *Toy Story*, Buzz Lightyear, as a way of reaching out to my younger audience, and eating fondue for my older audience, just to let them know I feel them every bit as much as my teenaged fans. Yeah, it might have freaked some people out to hear me rapping at first, but they quickly embraced it, and I have to admit, that felt really good. The funny thing about "Boyfriend" is it may be the 8th best song on the album. I love them all.

#Believe

# RIGHT HERE

"Right Here" is one of my favorite songs on *Believe* because I worked on the lyrics and the melody, so I got to build this track from the ground up. It's such a smooth, chilled song that really gets its point across. And, I had the opportunity to work with Drake, who I totally respect. He's so cool and down to earth, plus he's always got some great melodies and vocally we are on the same vibe. Drake and I wanted to work together because we knew we could create a great song for our fans.

"From a vocal producer and a singer's standpoint, what people like about Justin first, is that he has the 'it' factor that we hear everyone talk about. The thing that makes him a superstar. But when you hear him sing, the reason you like it is that he sings from his heart and you can tell. When he sings, he means everything that he is saying. He isn't just singing songs, he is giving everything he has to his fans. Justin will only sing songs he feels something for. If he has any reservations about it, he is not going to sing it and put that authenticity into it that makes people connect with his music."

**—Kuk Harrell**

Our only motivation was to come up with a song that felt right for both of us, and I totally think we did that with "Right Here."

So I'd had this idea in mind to write a song about always being around if someone important needs me. I kept thinking about them not needing anyone else's shoulder to cry on because I would always be right here for them. On another note, I have so many people in my life who have given me that sense of security and I wanted to let them know I'd do the same for them. Loads of people have done a lot for me over the years, and I am extremely grateful for their support—everyone from my mom, dad, grandparents, Scooter, and our entire team, but most of all, you, my fans, who have never let me down. It's because of you that I get to do the thing I love most, and that's really cool. I made a promise to myself and my fans that I am never going to leave them and I know they are never going to leave me. I am going to be someone who is going to change but I am always going to be there—I will still be KidRauhl.

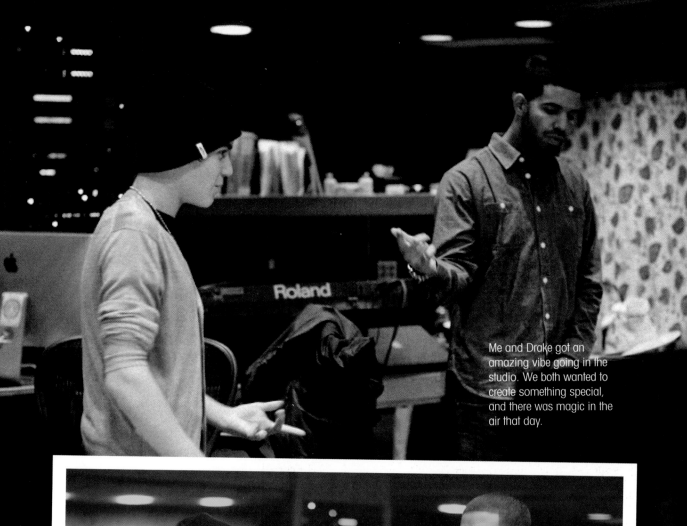

Me and Drake got an amazing vibe going in the studio. We both wanted to create something special, and there was magic in the air that day.

Even when you aren't feeling well a good prank feels sooooo good. What I have is a once-in-a-lifetime opportunity and I'm having a blast. --

Time spent planning and pulling off a great prank is time well spent!

# RISKY BUSINESS

Joking around with Gabe Saporta from Cobra Starship.

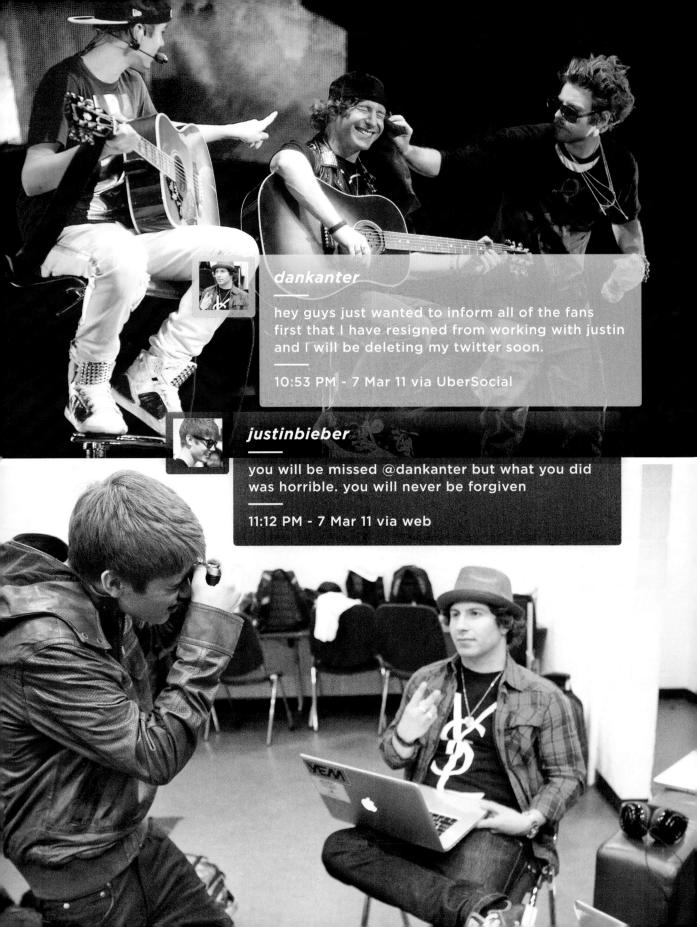

**dankanter**

hey guys just wanted to inform all of the fans first that I have resigned from working with justin and I will be deleting my twitter soon.

10:53 PM - 7 Mar 11 via UberSocial

**justinbieber**

you will be missed @dankanter but what you did was horrible. you will never be forgiven

11:12 PM - 7 Mar 11 via web

# PRANKING DAN

Everyone knows I love a good practical joke and no one—and I mean no one—is immune. OK, there are a few people who I have called a truce with (you know who you are), but for the most part, I will take whatever chance I get to pull off a great prank.

While we were on our European tour, I made Dan Kanter my latest victim by playing a prank on him in Dublin, Ireland. He never even saw it coming—a trait that makes me really good at pulling off these types of practical jokes and everyone else a sitting duck.

We were staying in a hotel outside of the city, so there wasn't much to do. When I get bored, I begin to plan my next target, and that's pretty much what happened that day. The prank went down over Twitter. We all know rumors spread like wild fire, especially through social media. That's when I got the idea to get a hold of his cell phone and go for it. I locked myself in the bathroom at the hotel and sent out a tweet from his account that read, "Hey guys just wanted to inform all of the fans first that I have resigned from working with Justin and I will be deleting my twitter soon." As soon as I hit the "tweet button" on his phone, I verified the information on my Twitter account too. "You will be missed @dankanter but what you did was horrible. you will never be forgiven."

Dan's phone started blowing up with messages from people wanting to know what happened! Even his grandmother called out of concern. Much to my surprise, our fans were shocked—so much so that Fredo decided it was time to put an end to the joke by tweeting: "@dankanter don't worry. I saw Justin tweet that from your phone. Everyone FALSE ALARM! LOL *as Dan fights Justin for his phone back*"

Just to make sure everyone got that it was only a joke, Dan confirmed it was all a big prank, tweeting: "Got pranked by JB. Guess I should cancel those auditions for @davematthewsbnd @phish @metallica and @bobdylan and get #REVENGE"

As for me?

Well, trying to pull one over on my millions of Twitter followers (you know I love you guys!) seemed like a funny idea, but looking back, maybe it wasn't.

Oh, who am I kidding…? It was hilarious!

I don't know why, but pranking Dan is a lot of fun for me. Maybe it's because he is such a sweet guy who has a big heart and is always kind to everyone. Anyone who meets Dan thinks he is the nicest person on the planet, so when I mess with him, it's just…well, funny!

One of the best pranks I've ever pulled off was after doing the Juno Awards in St. John's, Newfoundland. This one took some serious preplanning. Three weeks ahead of time, I told Dan I was planning a surprise for him in St. John's. I didn't tell him who it was, but I said that I had arranged a private dinner with one of his favorite artists after the Junos. I told him to bring a suit because it was going to be a formal event. Dan traveled around with a garment bag for weeks, lugging that suit everywhere we went until we got to Newfoundland. Believe me, it's a hassle to try and keep a suit from wrinkling while touring.

Dan spent those three weeks asking everyone on tour if they knew who he was going to meet. Of course, everyone was in on the joke so they kept quiet or responded by simply saying, "You'll see." The suspense was driving him crazy and I loved every second of it!

Every time Dan came to me and asked who he was meeting, he'd take a wild guess.
"Is it Dylan?"
"You'll see," I'd say.
"Elton John?"
"You'll have to wait bro…"
"Bon Jovi?"
I'd just smile and say, "You'll find out soon enough."

For whatever reason, Dan convinced himself it was Bon Jovi, so he started reading up on the band, memorizing each member's bio so he'd be totally in the know when they met.

The night of the dinner, I sent a car to pick Dan up and take him to the restaurant. When he got to the front door the manager met him and brought him back to a room where a large security guard was waiting. The security guard spoke very little English, and when he did speak, he had a thick German accent, so he didn't say much of anything when Dan tried to talk to him. The manager seated Dan at the table and told him to wait there.

Dan actually began to sweat, wondering who'd be coming through the door. Five minutes went by before the bodyguard said to Dan, "Are you ready to meet the band?" At this point, he was visibly shaking as they walked into another private room.

When he walked through the door I was standing there in a hoodie sweatshirt with the rest of the gang, who were all dressed in casual clothes laughing hysterically at Dan who was in his suit! Dan thought it was hilarious. I actually had a dinner waiting for everyone, so in the end it wasn't so bad—except maybe for Dan who was in his suit for the rest of the night.

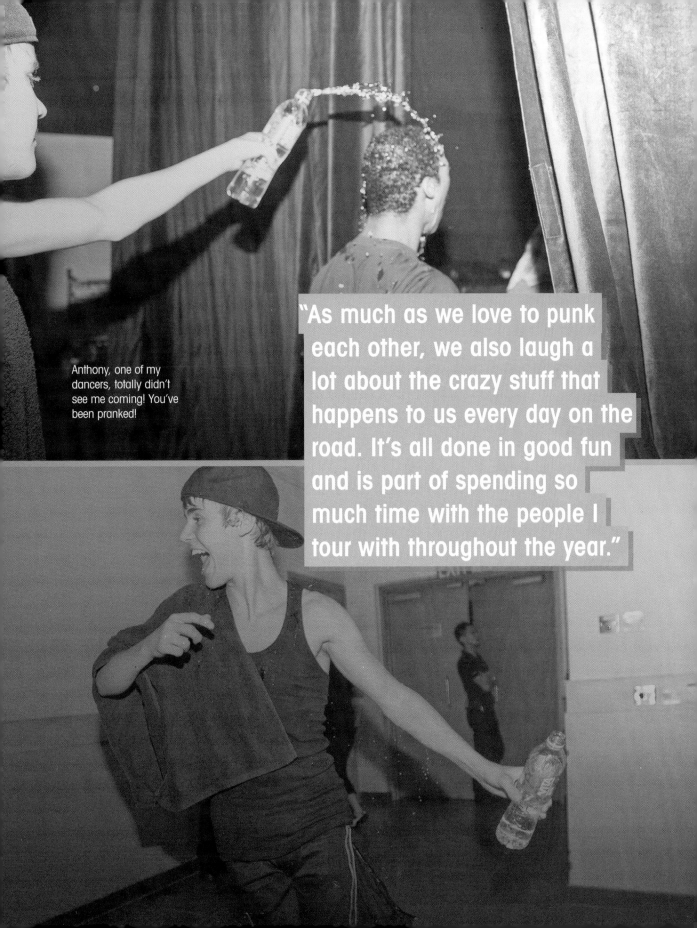

Anthony, one of my dancers, totally didn't see me coming! You've been pranked!

"As much as we love to punk each other, we also laugh a lot about the crazy stuff that happens to us every day on the road. It's all done in good fun and is part of spending so much time with the people I tour with throughout the year."

"I'm still young, so I can rock whatever. I have developed my own style as I've built up my swagger."

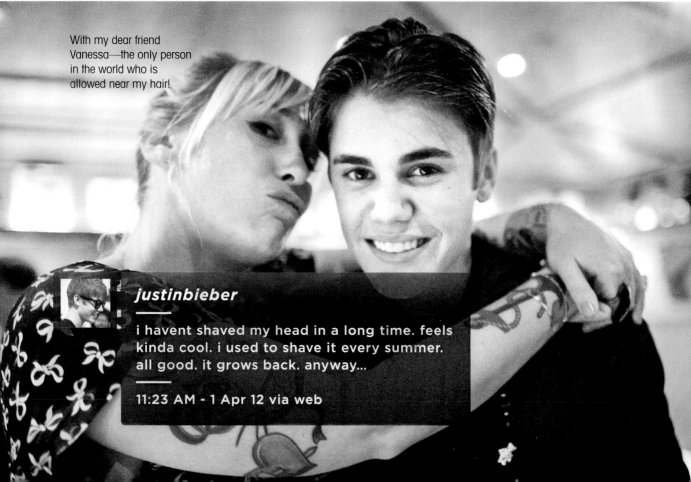

With my dear friend Vanessa—the only person in the world who is allowed near my hair!

**justinbieber**

i havent shaved my head in a long time. feels kinda cool. i used to shave it every summer. all good. it grows back. anyway...

11:23 AM - 1 Apr 12 via web

# SWAGGY

Yeah, I know what you're thinking. I can't really explain the reason why, but people sure do like to talk about my hair. I'm just a regular guy who wakes up like everyone else and puts clothes on —usually a hoodie, jeans, some fresh kicks, and a baseball hat. I'm not really sure how something as simple as a haircut catches on, but mine sure did. If you look back at music icons through time, everyone from Elvis, the Beatles, Billy Idol, and Michael Jackson have all influenced style, especially hair styles, so I guess it makes sense that my haircut might do the same.

I wore my signature style for several years until one day I decided that I wanted to do something different—you know, change my look like David Beckham does. My hair stylist, Vanessa, is the only person I let cut my hair. We met at my first professional photo shoot ever. She was given the task of cutting my hair so that it still looked suitable for me. I felt comfortable with it and it captured what she referred to as my "Canadian hockey helmet hair." I think that meant she didn't like the look I had going. I was still recovering from the worst haircut ever—what I painfully referred to as my Bart Simpson cut. Needless to say, I was hesitant to let anyone mess with my hair ever again. I am definitely vocal about what I like and don't like, so I was placing a lot of trust in Vanessa for that first cut. But once she gained my trust she gained my loyalty—and I have never looked back.

So when it came time to change things up, Vanessa and I talked it through and we were on the exact same page—as my music and career were growing and evolving, so did my personal style—including my hair. OK, so hang on. Breathe deeply. Hold the phones. Flip your hair one last time and for God's sake, someone, please alert the media because I got—a haircut! Really? It's a haircut, people! Just a haircut. The fabric of the universe wasn't altered—just the length of my hair!

Believe me, there are days I've thought about shaving my head completely—you know to make myself a little more aerodynamic on the basketball court or channel my inner Michael Jordan. Could you imagine the media frenzy that would cause? Although I'd likely never really shave my head, in 2011 I pretended that I did on *Jimmy Kimmel Live*—or, as I like to refer to him, "Bieber's barber." Don't worry, it was just a joke and Vanessa doesn't ever have to worry about Jimmy taking her job!

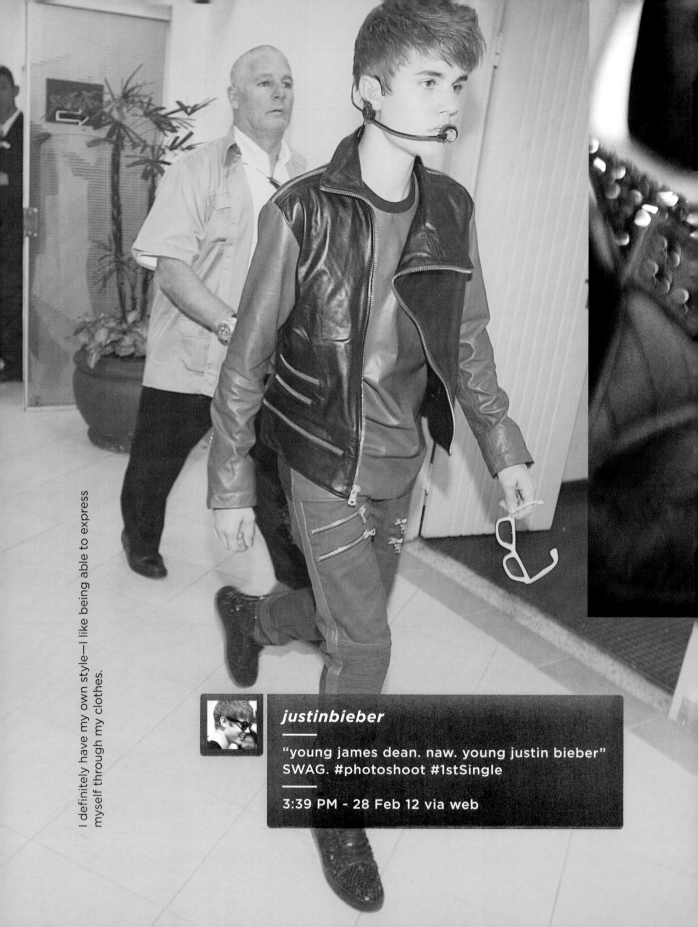

I definitely have my own style—I like being able to express myself through my clothes.

**justinbieber**

"young james dean. naw. young justin bieber" SWAG. #photoshoot #1stSingle

3:39 PM - 28 Feb 12 via web

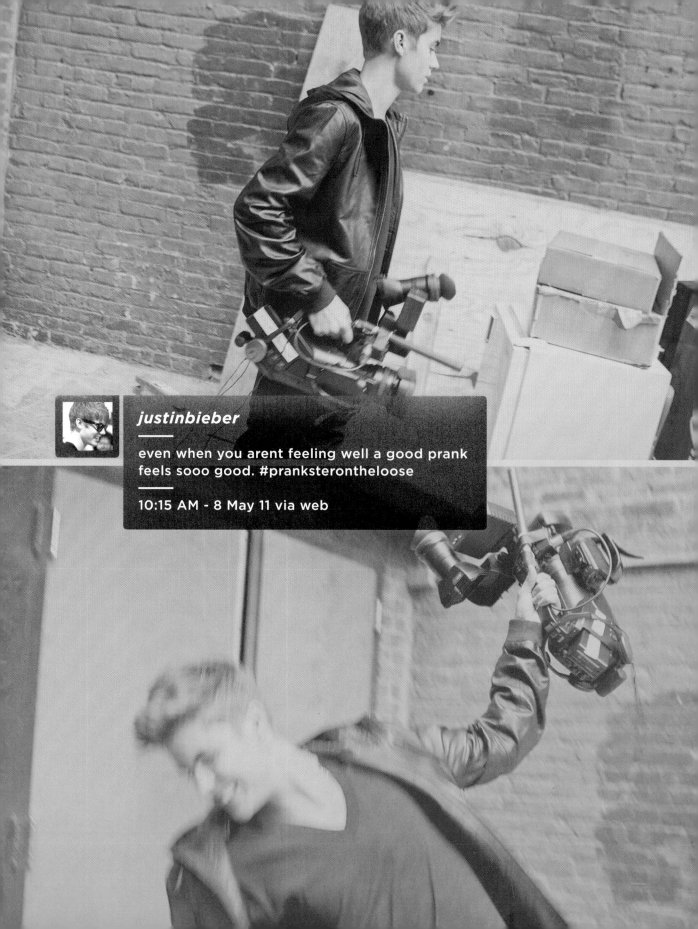

**justinbieber**

even when you arent feeling well a good prank
feels sooo good. #pranksterontheloose

10:15 AM - 8 May 11 via web

# PUNK'D

Given my love of practical jokes, it only made sense that after five years of it being off the air I became the first guest host on MTV's revival of their hit show, *Punk'd*. The first show we did involved planning my biggest prank ever.

And who was my unsuspecting victim? My good friend Taylor Swift.

I called and asked Taylor if she would come over to my beach house and help me write a song for my album. Taylor agreed and even asked me if I would do a surprise open for her at her show later that week in Los Angeles.

While we were at "the studio" (actually a house in Malibu rigged by the *Punk'd* team to look like an actual beachside recording studio), I convinced Taylor to set off some fireworks with me, one of which "accidentally" landed on a boat which was hosting a wedding party, setting fire to it—meaning the guests (who were all actors) had to swim to shore for their lives. Taylor totally believed she blew up the boat! She is such a sweet and kind person and though Taylor didn't start crying, she was very freaked out thinking she had ruined the strangers' wedding. By the time the "bride" swam to shore, Taylor was so apologetic, saying, "Oh my God! I'm so sorry!" over and over to the bride and groom, who weren't very happy with her.

I, of course, was totally in on it—making Taylor feel responsible for the situation until I finally had to tell her what was up and that she had just been *Punk'd*.

Thankfully, she started laughing and said, "How could you do this to me?"

Another episode I did on *Punk'd* involved the old "bait and switch" on Miley Cyrus. She thought MTV had planned a prank where she was supposed to punk me, but what she didn't know was that the joke was really on her because it was all an elaborate setup from the start. The concept was to make Miley think she's set up some skateboarders to harass me about where I parked my car, but in reality I was going to make it look like I completely snap and start beating up the kids in the parking lot. Miley watched the entire scene unfold on the video monitors in the trailer where she was hiding from me, still totally unaware that the joke was actually on her. After I start beating down the alleged skaters, Miley freaked out and immediately wanted to call the prank off. She pleaded with the producers to stop shooting and help the kids in the parking lot, who at this point were laying on the ground as if they were really hurt. Before she could get out the door, I took off running so she wouldn't be able to confront me on the spot.

A few minutes later, I suddenly reappeared to let her know that not only had she just been *Punk'd*—I also wanted her and the rest of the world to know that I am un-punkable! Her reaction was pretty hilarious and I loved every second.

I hope I get to do more shows in the future because it's the type of pranks I love to pull and MTV and the producers of *Punk'd* can help me scheme more elaborate stunts than I could ever pull off on my own. My former stylist and good friend Ryan is working with the team at MTV and *Punk'd* now, so I am sure they haven't seen the last of me!

I wonder who my next victim will be?

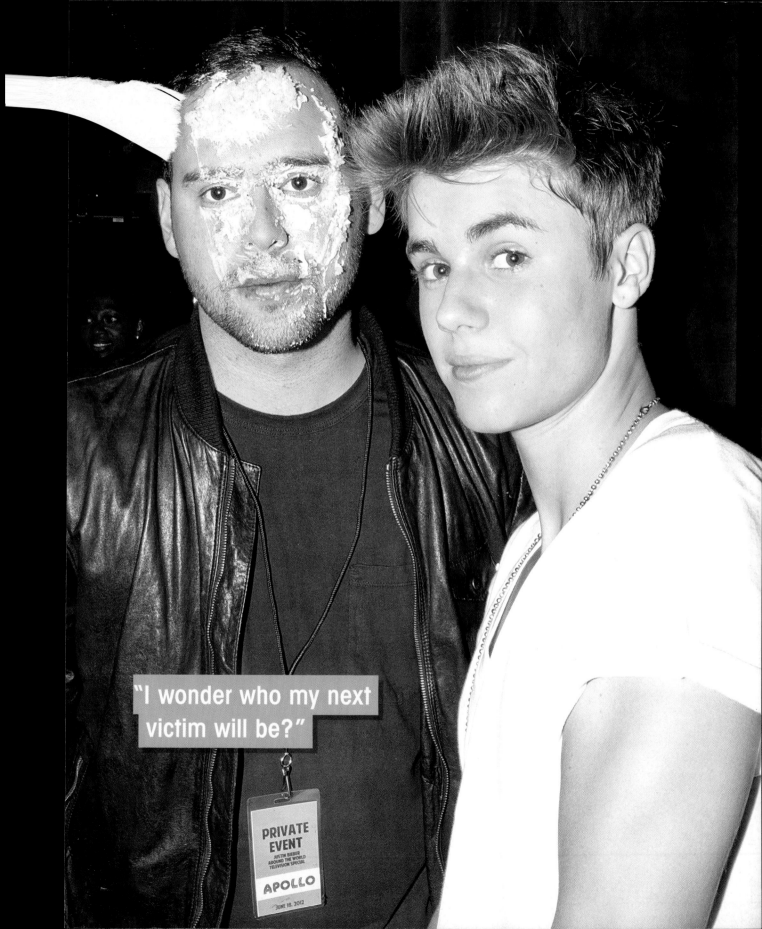

"I wonder who my next victim will be?"

PRIVATE
EVENT
JUSTIN BIEBER
AROUND THE WORLD
TELEVISION SPECIAL

APOLLO

JUNE 16, 2012

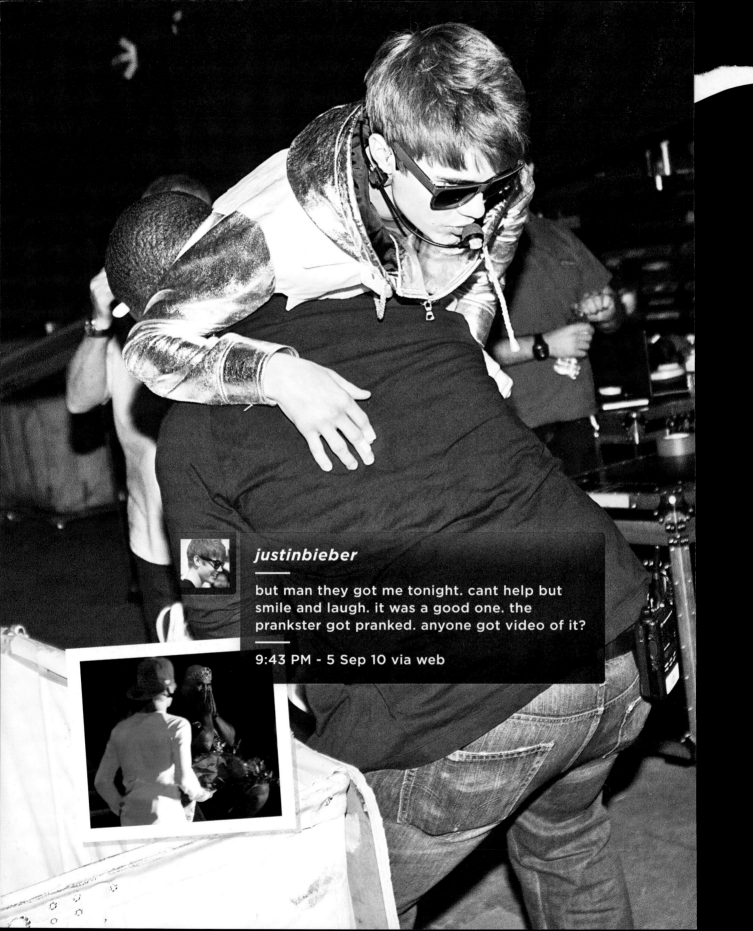

**justinbieber**

but man they got me tonight. cant help but smile and laugh. it was a good one. the prankster got pranked. anyone got video of it?

9:43 PM - 5 Sep 10 via web

# ONE LESS LONELY...BOY?

Caracas, Venezuela
October 25, 2011

Whenever we get toward the end of a tour, the practical jokes among the crew and me become kind of a regular thing. We've been on the road for months and everyone gets a little punchy. I guess we like to keep things interesting, and believe me, they are!

By now you know I can't be punk'd, but I will admit that my crew got me pretty good on September 5, 2010, at the Maryland State Fair show during the North American leg of the *My World* tour. At one point in every show I have a tradition of bringing a girl from the audience up on the stage so I can sing "One Less Lonely Girl" and present her with a dozen roses. Usually, this is a very special moment for the both of us, but at this particular show my crew decided to pull one over on me.

Boy did they ever. And I mean, BOY!

It's not easy to get something past me, but my crew decided it would be hilarious to bring Marcus Wade, our special effects operator, up on the stage instead of a girl from the audience. Marcus is a big burly dude who definitely looks like he does a lot of heavy lifting. He's hardly what I expected, so when I saw him sitting atop the stool in the center of the stage, I practically stopped cold in my tracks.

"Hold up. That's a grown man!" I said to myself.

But I did what I had to do and kept right on singing, changing up the words to "One Less Lonely Boy" without missing a beat.

There was no way I was going to give Marcus a dozen roses, so I handed those to an audience member in the front row. I made my way over to Marcus, who was reaching out to me like a lovesick puppy, only instead of hugging him, I gave him an open-handed smack across the top of his shaved head. Knowing I had just been pranked in front of an entire audience, I did the only thing I could think to do in the moment—I grabbed my general manager, Allison, from backstage, as I knew she was the mastermind behind pulling this off. I brought her out so I could hug her and avoid any contact with Marcus. Yeah, it would have been the perfect plan, except Marcus picked me up in his arms and carried me off stage like a little rag doll. Good one, Allison—just remember, paybacks can be brutal!

I don't think of myself as powerful. If anything, my fans are powerful. It's all in their hands. If they don't buy my albums and see my shows, I go away.

--

I love my fans, wherever you come from and whoever you are. I'm so lucky to have people like you, and I always try to make you proud.

# CHAPTER 10
# ALL ABOUT YOU

# BELIEBERS

I have the best fans in the world, but some of them have become what we refer to as "Super Fans," meaning fans that follow me around from city to city, everywhere I go. (You know who you are!) They somehow show up in the front row at concerts during various legs of my tour. One fan, Teddy, came to see me in Paris, Zurich, and Israel! Now *that's* dedication.

We were touring in Australia for the first time ever, so Scooter was getting tons of requests from every media and press outlet for interviews with me. We also got a tweet from @JBSource, a Twitter-based fan club that has 90,000 followers of their own. It turned out that the two girls who created it were coming to my show. The girls somehow got to Scooter to see if they could interview me for their Twitter page. They wanted to do a video interview and post it for the other kids to see. We had already turned down over 100 different outlets, but we both knew we had to make time for these girls. Scooter said they were the most important interview we could do there.

And man, was he right.

We brought in the two girls, one of their dads and two of their friends. I loved doing that interview because I totally knew who they were. It turned out that their video was one of the most viewed videos of that week—all of the fans on their site watched it, which was awesome for me because speaking directly with my fans is one of my favorite things to do.

"The picture on the right was taken backstage during a meet and greet in Santiago, Chile. The little girl in my arms slept the entire time. I couldn't help but love that she was unimpressed to be backstage at a Justin Bieber concert—it was kind of refreshing and very sweet."

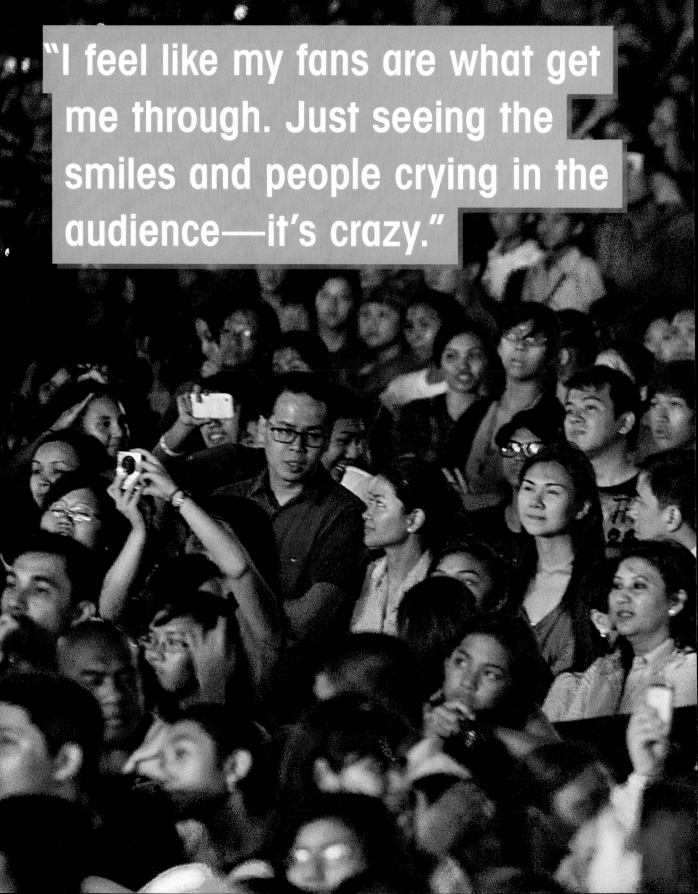

"I feel like my fans are what get me through. Just seeing the smiles and people crying in the audience—it's crazy."

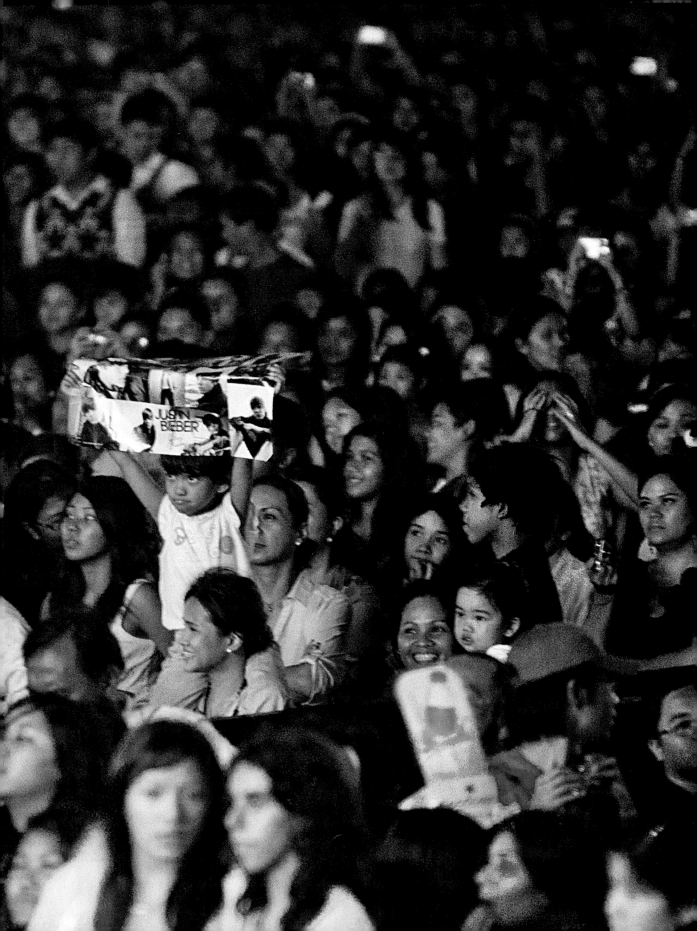

# THE RUNNING OF THE FANS

**Barcelona, Spain**
**April 6, 2011**

Before playing in Barcelona, I'd only done one other general admission show and I vowed I'd never do another ever again. Since there are no assigned seats, everyone jams the arena and tries to get as close to the stage as they can. It's like one giant mosh pit. The crowds get so crazy that I didn't want anyone to get hurt. However, the Palau Sant Jordi Arena in Barcelona only does general admission shows, so I had no choice but to go on with the show as planned. It had been a really hot and humid day, and people had been waiting outside the arena for hours in the sun. We arranged to have water handed around to keep everyone hydrated, but people were passing out everywhere.

Once they were allowed inside the arena it was an insane scene, like watching the famous running of the bulls, except it was people charging the stage for their "spot." Thankfully, no one got hurt in the stampede, but we were all concerned because of the heat and the size of the crowd. The temperature inside the arena was worse than being outside because the air was still and humid. We had extra medics on hand and lots of extra security for that show, and besides a few fainting fans along the way, it pretty much went off without a glitch.

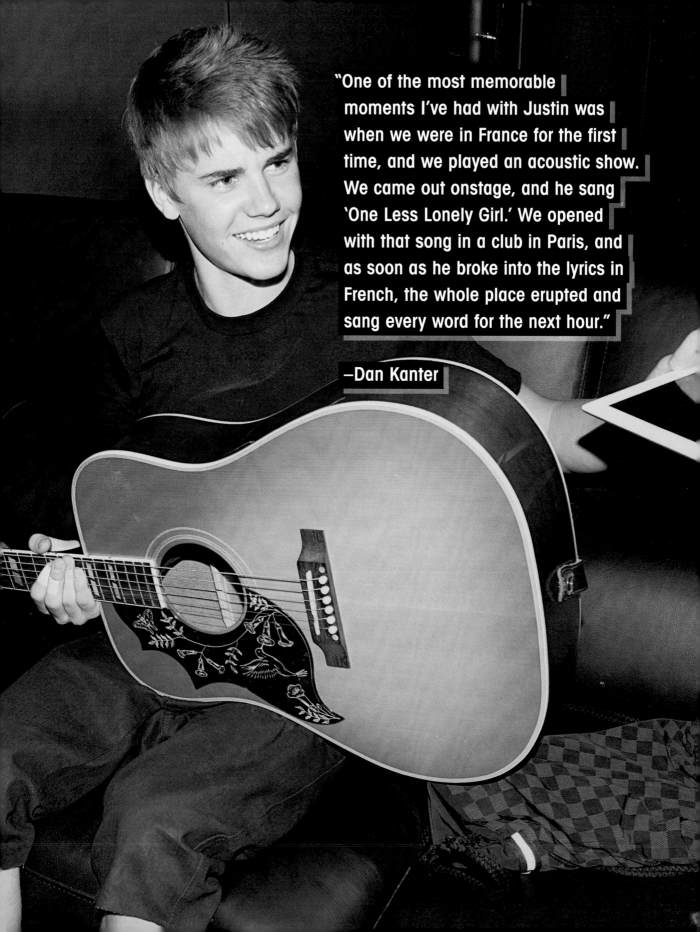

"One of the most memorable moments I've had with Justin was when we were in France for the first time, and we played an acoustic show. We came out onstage, and he sang 'One Less Lonely Girl.' We opened with that song in a club in Paris, and as soon as he broke into the lyrics in French, the whole place erupted and sang every word for the next hour."

—Dan Kanter

# MA CHERIE

Paris is a city that holds a lot of special memories for me throughout my career. One of my most unforgettable was an early performance Dan and I did for 50 winners of a radio contest at the Universal music offices. We were in a board room singing a couple of acoustic songs when everyone started to notice a loud, almost thunderous noise coming from outside. Thousands of fans had somehow figured out where we were and had randomly showed up. Back in the early days, it wasn't unusual for me to throw a tweet out there to say I would be at a particular radio station promoting my song, knowing that would get the local fans to show up wherever I was. I figured that when the station manager could see all of these kids gathered outside their station, he'd have to play my records. But for this particular appearance in Paris, I hadn't said a word to anyone about where we'd be that day, so it came as a huge surprise to me that they showed up to my label's offices to show their support for my music. I was totally blown away.

There was a beautiful stone balcony outside one of the offices that looked like it was straight out of *Romeo and Juliet*. I thought it would be cool if Dan and I would just go out on the balcony and play for everyone—so we did. It was reminiscent of what I can only imagine Beatles fans saw when they famously played on top of the Apple Records building in London back in 1969. It's one of the few times I have ever done anything like that. It was a real treat for everyone, but most especially for my fans who helped get me to where I am today. It was just a small gesture, but it was my way of saying thank you and showing my absolute appreciation.

# CHAPTER 11
# FOREVER, MICHAEL

Michael Jackson is my inspiration. He was the most amazing singer, songwriter and entertainer that's ever lived and I want to emulate his career as much as possible.

--

I've spent hours studying Michael Jackson's moves. If I can be even half the performer he was, I'll be happy.

# FOREVER, MICHAEL

**Hollywood, California**
**January 26, 2012**

I was super honored when my team came to me to say we were invited to the ceremony immortalizing Michael Jackson at the Hollywood Walk of Fame. They explained the family personally wanted me there because I was the only artist of the new generation they felt shared similar traits with Michael. It was such a privilege to be included in this very intimate and emotional event, especially to be acknowledged by my hero's family in such a way. I was really looking forward to meeting his kids, his mother, and his brothers too.

I was a little nervous when Michael's daughter Paris introduced me, as this was such a big day for everyone there. As I spoke, I explained that Michael was more than an entertainer to me—he was also an inspiration. Most people will remember him for his dancing and singing, but I want to remember him for the man he was and the contributions he made to the lives of so many. His actions inspire me to be the best I can be—because that's what Michael did. He was always dancing and practicing and tapping into his creativity. I remind myself of that every chance I get.

After the ceremony, Mrs. Jackson told me that her son would have enjoyed seeing me as a performer and would have wanted to pass his legacy on to someone like me. I was left speechless by her words. And then Paris came over and said that her father would have wanted to be a mentor to someone like me. Hearing her say that was, well ... it was completely surreal.

As if I hadn't already been humbled by the family's kindness, Michael's brothers came up to me and said, "We have a present for you." They gave me a replica of Michael's famous red leather jacket he wore in *Thriller*. It was the exact same size as Michael's. They asked me to put it on and take pictures with them. When I did, we all laughed because it fit me perfectly. I guess we are the same size. Best of all, the jacket was actually signed by Michael and all of the brothers. CRAZY!

Being a part of this celebration was a moment that, as a kid, I never dreamt would ever happen. But it did, and it was the kind of day I didn't want to end. I was surrounded by people who loved Michael Jackson, and his family embraced me like I was one of them. It meant the world to me. It is by far one of the favorite things I have ever done, and it was one of those days I will never forget.

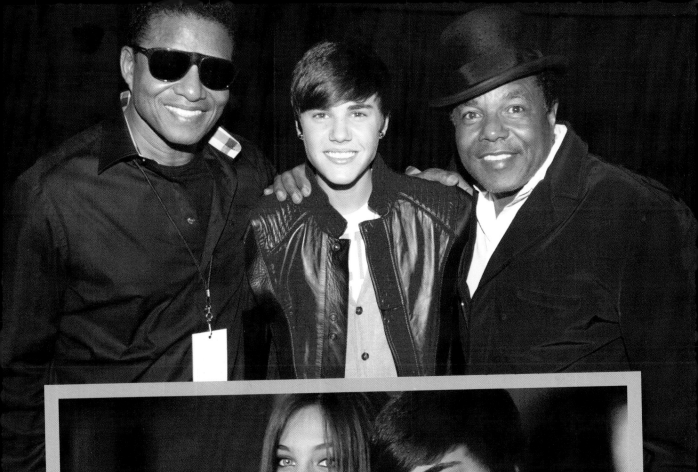

**justinbieber**

just left the Michael Jackson ceremony...i dont get nervous usually but i was really nervous. to be with his family. he was the greatest!

2:15 PM - 26 Jan 12 via web

**justinbieber**

@ParisJackson thanks for having me today and the things you said. your dad will always be my mentor. his career is all i study. #THEGREATEST

10:11 PM - 26 Jan 12 via web

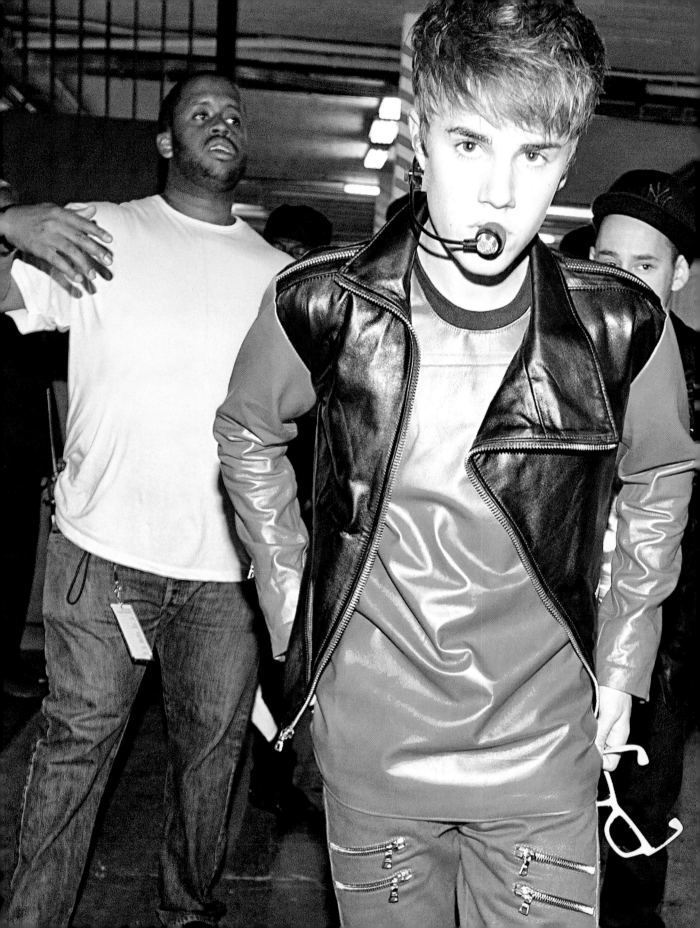

# SCOOTER:

A lot of people compare Justin growing up in front of us all to Michael Jackson—saying they grew up the same. But they didn't. Michael grew up in a group, and as a kid he didn't grow up in a time where there were camera phones, Twitter, Facebook, and paparazzi. Michael knew nothing of this kind of technology early in his career because it didn't exist. He knew what it was like to grow up famous, but he never knew what it was like to be exposed 24/7. Until he went on to pursue his solo career, he also had no idea what it was like not to have anyone else in a group to rely on. If Michael didn't feel like doing an interview, Tito, Jermaine, or Marlon could always fill in. If Michael wanted to do something like go to the park, he could. Whatever fans saw, only they saw. Nothing could go viral. There were no cell phones with cameras and no internet back then. That memory of seeing their favorite pop star stayed with those fans that were lucky enough to be in the park at the same time.

Justin can't rely on anyone to do an interview but him. When he goes to the park and the fans have an experience, they tweet, post it on Facebook, and take photos the entire world can see in an instant. It is a lot of pressure for anyone, but it's especially challenging for a kid who just wants to be a kid. Sometimes he likes it and sometimes he doesn't. This kind of exposure is all he has known since he was 14. His entire adolescence has been owned by the world.

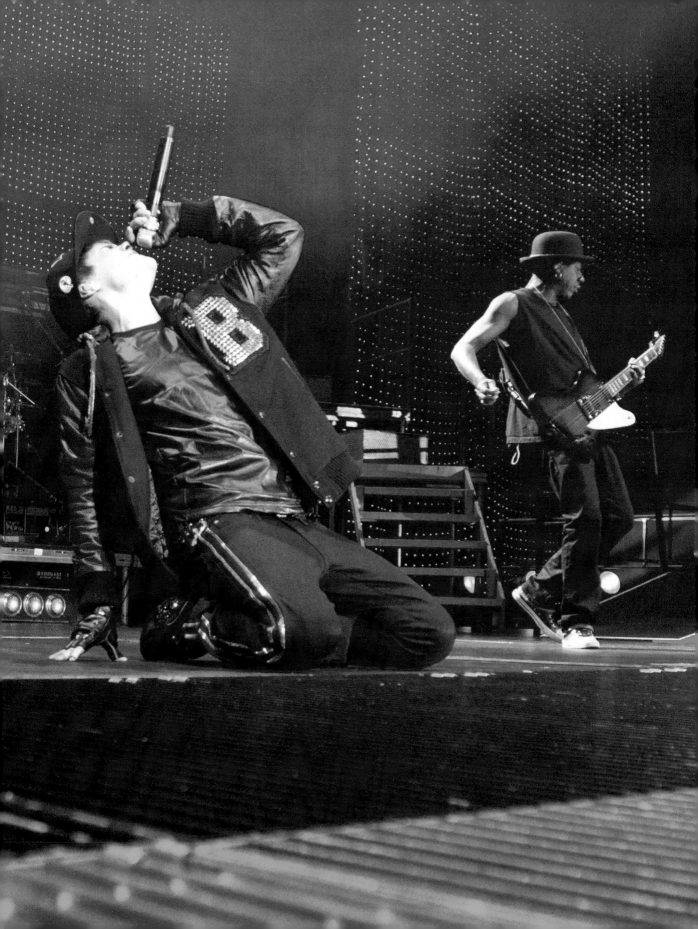

I really love playing stadiums—it is fantastic to look out and see that many people enjoying my music. And it's satisfying to know that you are positively affecting people all around the world with that music.

--

A quiet moment on stage in Caracas. I'm so grateful to be living this incredible life.

# CHAPTER 12
# JUST GETTING STARTED
## LEG TWO

# THE ULTIMATE SUITE LIFE

**Mexico City, Mexico**
**October 1, 2011**

I love performing because of the rush of it and being able to see the smiles on my fans' faces. Knowing that I can bring them happiness brings me happiness. That is what makes it amazing. Performing enables me to release whatever I am feeling and it takes me away. I just can't describe the feeling. A typical concert lasts about 90 minutes or so, but sometimes I may go longer, especially when the crowd is on their feet asking for more. I am so pumped up after a show that I can't really go to sleep for a couple hours after, so I'll head back to my hotel and play video games or watch a movie until I can finally fall asleep.

I was super excited to do our show in Mexico City because it was my first stadium show as the headlining act. I had done a couple of stadium shows back in June 2010. The first time was with Taylor Swift at Gillette Stadium in Massachusetts, and then at Wembley Arena in England for the Capital FM Radio Summertime Ball. I had actually played Wembley one time before those shows—a performance I will never forget because I broke my foot dancing on stage while singing "Baby." I was able to finish the song, but the moment I got off the stage, I broke down because I couldn't walk. I did my next 14 shows in a cast, which made dancing a little clumsy, but I somehow powered through with the help of my fans.

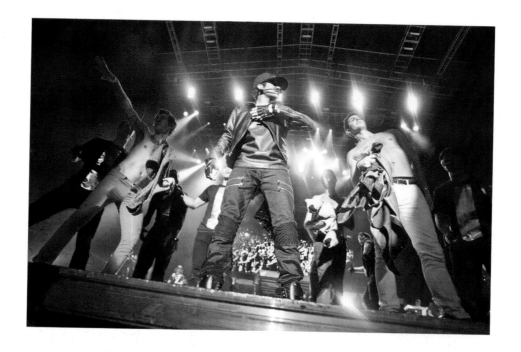

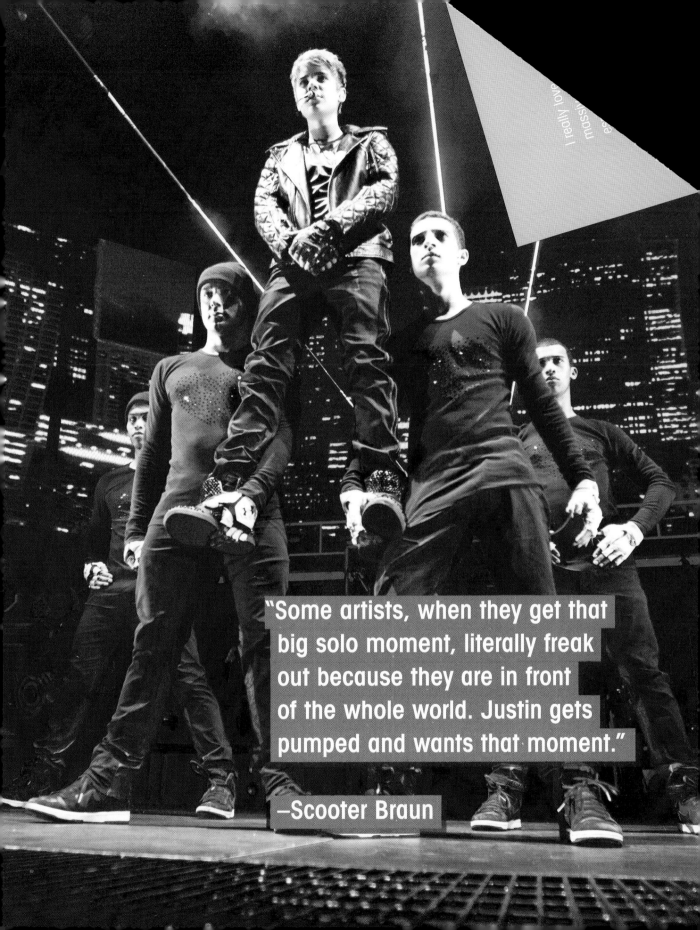

"Some artists, when they get that big solo moment, literally freak out because they are in front of the whole world. Justin gets pumped and wants that moment."

—Scooter Braun

playing stadiums because the
[  ]e crowds fire me up even more than usual,
[ ]pecially when everyone gets crazy! It is fantas-
tic when I look out and see that many people are
enjoying the music I made in a studio with only a
couple of people. And it's satisfying to know that
you are positively affecting people all around the
world with that music. There is a joy that comes
in realizing that moment on the stage. When you
have that many people in front of you and just
know they have been waiting for this moment too,
it's the most incredible feeling in the world. All I
want to do is deliver on that moment, have that
interaction with the crowd and never get off stage.

Mexico City was our second stop on
our South American Tour—we'd just
played Monterrey a couple of days before,
where the crowds were amazing. We
checked into our hotel really late at night.
Sometimes we stay at very fancy hotels
that are pretty traditional with old-school
furniture, and other times we stay at
cooler-styled hotels. The W Hotel in
Mexico City was definitely in the cool cat-
egory. When I walked into my room that
first night, I was stunned to see the hotel
had set up a basketball court in the dead
center of the room. Yeah, the room was
like one large loft space that was actually
big enough to house an indoor basketball
court. I have no idea how the hotel knew
all of my favorite candy, but they had bowls of
Watermelon Sour Patch candies, sour Skittles
and Sour Patch kids all around the room and
Michael Jackson DVDs by the large-screen TV.
Fredo and I stayed up and played basketball
for most of the night. Since I had a show the
next day I made myself go to bed, but believe
me, I didn't want to—it was like the room had
been custom made just for me.

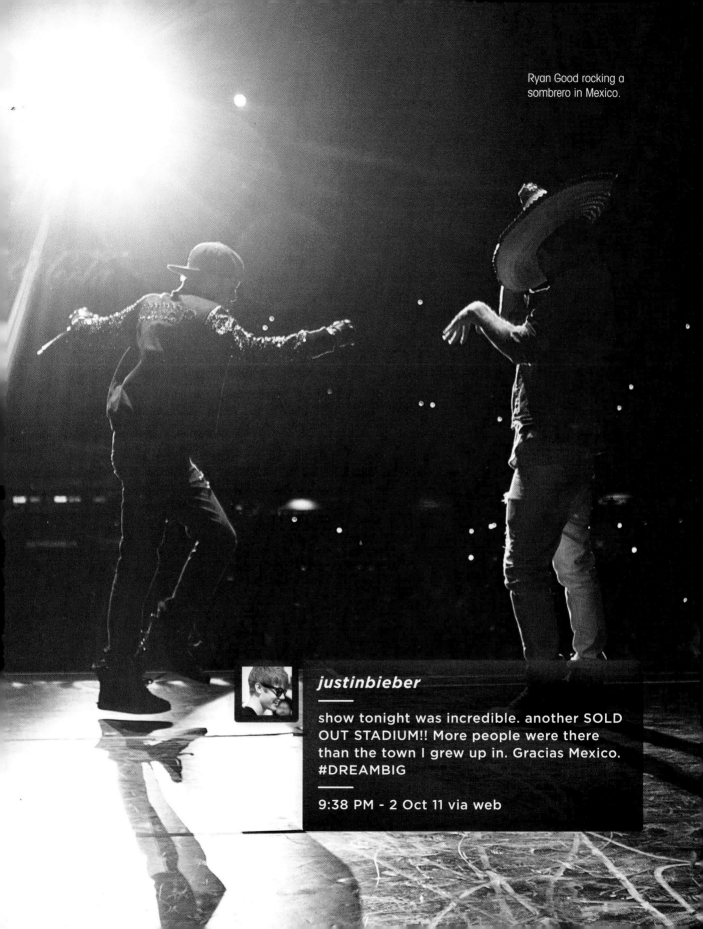

Ryan Good rocking a sombrero in Mexico.

**justinbieber**

show tonight was incredible. another SOLD OUT STADIUM!! More people were there than the town I grew up in. Gracias Mexico. #DREAMBIG

9:38 PM - 2 Oct 11 via web

When we came back to the hotel after my concert on the second night, I noticed a fog rolling out from under the door to my room. I had no idea what was happening, but when I opened the door I heard the theme music from *Rocky* playing and saw blinking white lights all around the suite. I was utterly blown away by the large boxing ring in the middle of the room. I was psyched because boxing has become a real passion of mine. I actually text Floyd Mayweather all the time for tips. He would have loved what was going on in that room and had he been there, we could have sparred. Oh well.

I hopped into the ring, put on some gloves and started punching the boxing mannequin they had placed in the ring instead. In fact, they had those dummies all over the room. Fredo, Ryan, and I spent the night goofing off, sparring, and having a great time.

The hotel had already gone above and beyond my wildest expectations, but when we came back to the room for the third night, they had created a mini-beach, complete with palm trees, sand, beach chairs, umbrellas, and Hawaiian music! I totally love the beach. In fact, it is one of my favorite places to chill out. And even though we were in Mexico, there is no beach in Mexico City, so the good people at the W Hotel brought the beach to me. I have no idea how they got all of these different attractions set up, but I am very grateful they did.

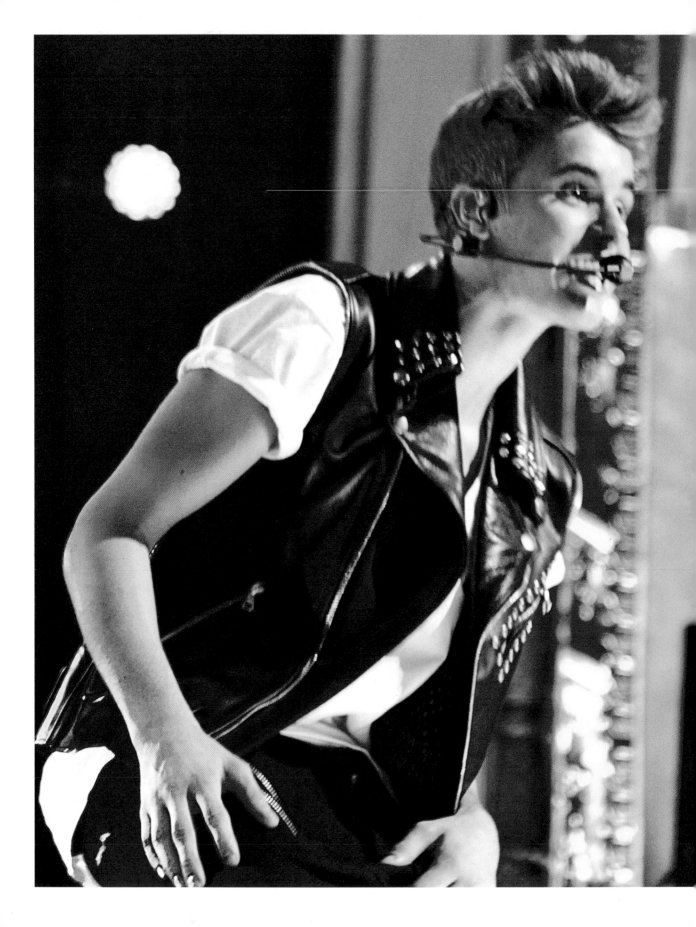

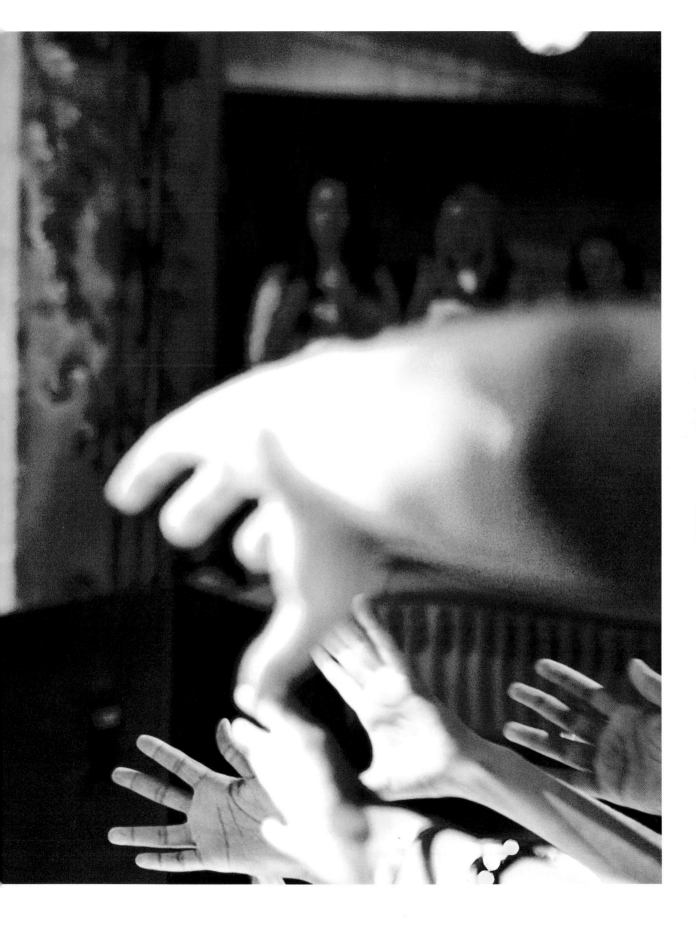

# A QUICK GETAWAY

**Buenos Aires, Argentina**
**October 12, 2011**

By the time we hit the South American leg of the world tour, we had been on the road for ten straight months. When we got to Buenos Aires, I couldn't wait to explore the city. The first day at our hotel was surprisingly calm. By the time I arrive someplace, my fans have usually found out where I am staying. They will camp out at the hotel for days hoping for a chance to say hello. I love seeing everyone, but it can sometimes get overwhelming. So it was a good surprise to see just a handful of people when we hit the streets that first day. I took a few minutes to say hello and sign some autographs before heading out.

First stop? We were in search of some sushi for lunch.

Alfredo and I came across a spot called Planet Sushi that reminded us of our favorite sushi restaurant back in LA. It was really good and super fresh. Afterward, I had a taste for ice cream so we asked around to see where we should go—we were told to head to a place called Freddo's. I had to laugh because I call Alfredo "Fredo" all of the time, so it only seemed right that we hit that spot for dessert.

When we got there, I discovered the best ice cream I've ever had, called *Dulce con leche con brownie*—basically a sweet creamy ice cream with brownie chunks. To this day I sometimes crave a scoop of that amazing combination.

Fredo and I had a great day exploring all of the beautiful sites in Buenos Aires. It's such a cool city. It's especially interesting to photograph, so Fredo and I decided to have an Instagram battle to see who could take the best pictures. We went all around the city shooting the local parks, museums, and other famous sites along the way. We posted our shots on Twitter and decided to let the fans decide whose pictures were better.

**ALFREDO**

**JUSTIN**

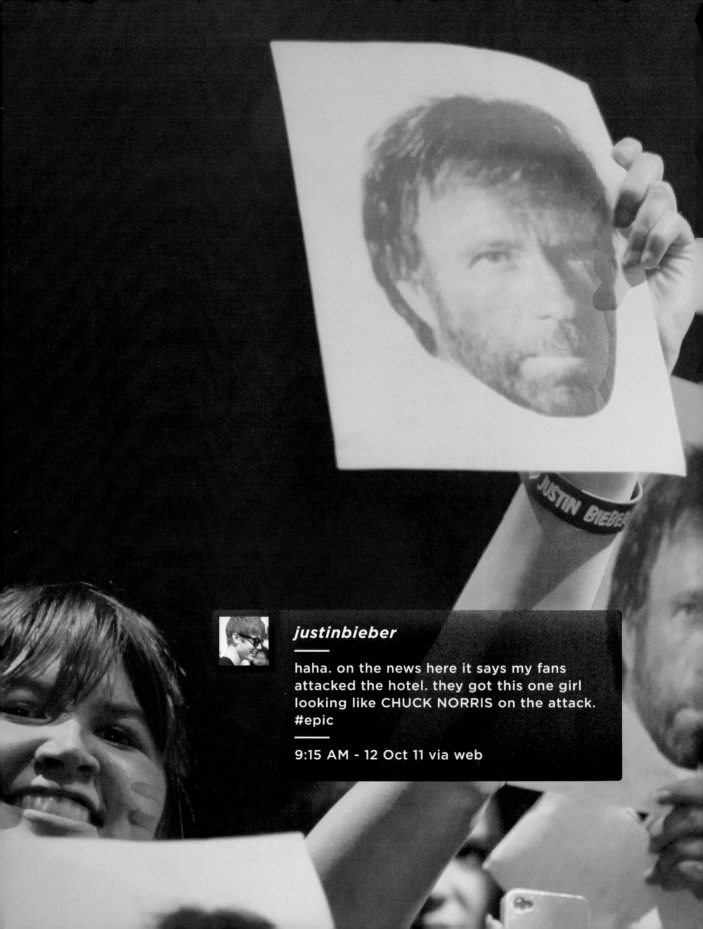

**justinbieber**
———
haha. on the news here it says my fans attacked the hotel. they got this one girl looking like CHUCK NORRIS on the attack. #epic
———
9:15 AM - 12 Oct 11 via web

It was sort of a slam dunk because I have, like, 20 million followers on Twitter and Fredo has, like, six. So yeah, I won the battle even though Fredo still believes he took the better shots—which he didn't. Mine were like great works of art.

As for his? Well, let's just say they were ok.

By the time we got back to the hotel, the word was definitely out that I was staying there because about a thousand or so fans were waiting for me out front. We found a way to go through the back of the hotel to avoid a stampede and spent the rest of the night playing my favorite video game, *Mortal Kombat*. It was getting kind of late, but I was hungry and was definitely bored of eating hotel food. (After a while, it all starts tasting the same!)

When we had been out earlier, I noticed a TGI Friday's not far from the hotel. When you're on the road, especially in other countries, there's nothing like a taste of some familiar food, and Friday's is one of my favorite spots. I especially like their chicken sampler with fries and the strawberry lemonade slushies. When you're traveling for extended periods of time, a familiar place like Friday's just feels like a little piece of home, and at this point in the tour, I was ready for some good old-fashioned home-style comfort food.

When I told Moshe that I wanted to hit Friday's for dinner, he shook his head and said there was no way I could go. There were just too many fans and paparazzi outside and I'd never be able to get past them without creating a totally chaotic scene. Man, all I wanted was some chicken tenders—there had to be a way to make it happen.

Now, for those of you who may not know this, I am claustrophobic—like, really claustrophobic. I can't even handle more than a couple of people in an elevator without feeling sick. So when someone suggested I climb into the trunk of the car to make our getaway, I wasn't sure I could do it. But I also didn't want to stay at the hotel, so I took a deep breath and did it despite my fear of small places.

As the car pulled out of the driveway, Fredo and Carin rolled down their windows so everyone could clearly see that I wasn't in the car. Once they realized it was just Fredo and Carin, the hope was that no one would follow them so I could get out of the trunk and into the car when we were a few blocks away—or as we like to call it, out of the fan zone.

A couple of minutes after we pulled away I asked, "Are we clear?" I was talking to them through a small passageway in the middle armrest from the trunk to the back seat.

Unfortunately, my security team spotted two paparazzi following us, so there was no way we could pull over. I was beginning to feel closed in so I stuck my hand through the hole to hold onto Carin's hand. I needed to be in contact with someone so I wouldn't go into a full-blown panic.

Friday's was definitely out of the question because it was too close to the hotel and we knew the fans would quickly figure out I was there, so we had to go to plan B—back to Freddo's for some ice cream. Since the paparazzi tailed us the entire time, I was stuck in the trunk while Alfredo went inside with one of the local security guys to get us all some ice cream. Carin stayed in the car to keep me company. When Fredo got back into the car, he handed me my ice cream through the tiny opening, and I ate my cone alone in the trunk.

We drove around for another 20 minutes hoping the paparazzi would ease up, but they never did so we gave up on Friday's and headed back to the hotel. Thankfully, it turned out that Friday's delivers! It might have been good to know that before I got into the trunk!

# CHAPTER 13
# COMING UP NEXT

As I get into it more, I want to grow up as an artist, as an entertainer, and basically perfect my craft. I want to be the best that I can be.
--

I'm so lucky—I know why I'm here, and what pushes me to keep going. As I grow up I realize the future's there for the taking—and I'm planning to take it by storm.

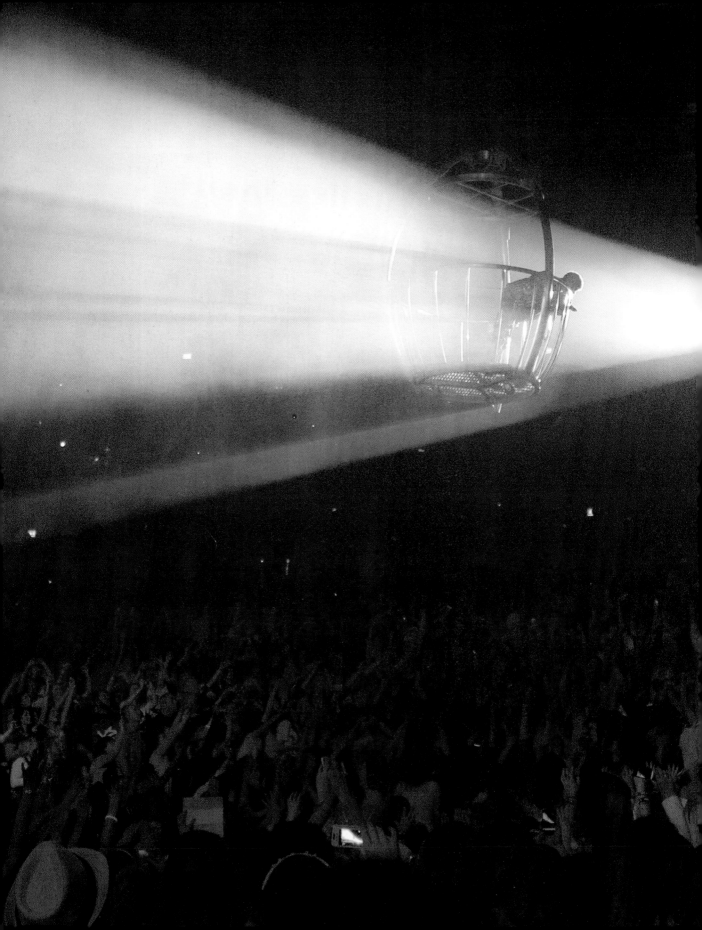

A lot of people have asked me what I think my future looks like. I really don't know how to answer them. I am still so young and have a lot I still want to do. When I think about the future, I hope to someday win a Grammy (or two), and maybe do a little more acting. I enjoy the process of making great music, from writing to recording to performing, and hope to keep on doing that too. You never know where life will lead, but one thing I know for sure, thanks to all of you, is that it's been one heck of a ride so far! I know we will have many more journeys and stories together, but as those begin I just need you to know that you all are the reason that I believe. You all are the reason that I am where I am, and even when times are tough, you all make every moment worthwhile. So to put it simply, I just have two words for you ...

**THANK YOU!**
**I LOVE MY BELIEBERS**

**JUSTIN**

**#ALWAYS GIVE BACK**

**If you'd like to know more about my charities of choice, check out the following:**

Pencils of Promise focuses on building schools and sustainable education programs. By forming long-lasting, collaborative relationships with communities, they increase access to quality education and positively impact students and parents in high-need communities throughout Laos, Nicaragua, and Guatemala. For more information on Pencils of Promise, check out

**www.pencilsofpromise.org**

One of my favorite organizations to be a part of is the Make-A-Wish Foundation. Every chance I get, I do my best to meet children through them in various cities around the world. I've met so many amazing and brave kids throughout the years—each one unforgettable in their spirit and passion. All of the kids were super happy, and it was great to see the smiles on all of their faces. A lot of times, meeting me is their last wish, and that is so special. Since 1980, the Make-A-Wish Foundation has given hope, strength, and joy to children with life-threatening medical conditions. It's an organization that grants a child's wish in the U.S. every 40 minutes. For more information go to

**www.wish.org**